DIANA
of the
DUNES

DIANA
of the
DUNES

THE TRUE STORY
of Alice Gray

JANET ZENKE EDWARDS

Published by The History Press
Charleston, SC 29403
www.historypress.net

Copyright © 2010 by Janet Zenke Edwards
All rights reserved

Front cover images: Map, *Westchester Township History Museum*; photo of Alice Gray, *Chicago History Museum*; and etching, *Earl H. Reed's* Voices of the Dunes, *Westchester Township History Museum*.

First published 2010
Second printing 2011

Manufactured in the United States

ISBN 978.1.59629.977.1

Library of Congress Cataloging-in-Publication Data

Edwards, Janet Zenke.
Diana of the Dunes : the true story of Alice Gray / Janet Zenke Edwards.
p. cm.
Includes bibliographical references.
ISBN 978-1-59629-977-1
1. Gray, Alice, 1881-1925. 2. Gray, Alice, 1881-1925--Legends. 3. Gray, Alice, 1881-1925--Relations with men. 4. Wilson, Paul, d. 1941. 5. Indiana Dunes State Park (Ind.)--History. 6. Indiana Dunes State Park (Ind.)--Biography. 7. Indiana Dunes State Park (Ind.)--History. 8. Women--Indiana--Indiana Dunes State Park--Biography. 9. Women hermits--Indiana--Indiana Dunes State Park--Biography. I. Title.
F532.I5E34 2010
977.2'98--dc22
2010020421

Notice: The information in this book is true and complete to the best of our knowledge. It is offered without guarantee on the part of the author or The History Press. The author and The History Press disclaim all liability in connection with the use of this book.

All rights reserved. No part of this book may be reproduced or transmitted in any form whatsoever without prior written permission from the publisher except in the case of brief quotations embodied in critical articles and reviews.

With love to David, Sarah and Anna
The next generation of Dunes storytellers

Contents

Foreword	9
Acknowledgements	11
Introduction	17
Ghost Story: Diana of the Dunes	23
Chicago Childhood	25
Ambrose and Sallie Gray	31
Phi Beta Kappa	37
From the USNO to Germany	41
Leaving Chicago	47
Driftwood	51
Surfacing in the Dunes	63
Diana of the Dunes	67
Fullerton Hall	75
Paul Wilson: Caveman	79
Murder in the Dunes	87
A Case of Libel	95
In the End	99
Afterword	105
Appendix A. Siblings	109

Contents

Appendix B. Paul Wilson, After Alice	113
Appendix C. Alice's Diary—Excerpts	119
Appendix D. Newspaper Article by Alice Gray	141
Appendix E. "Chicago's Kinland"—Essay by Alice Gray	145
Notes	147
About the Author	159

Foreword

Over the past thirty-five years, many would-be biographers of the legendary Diana of the Dunes have visited Westchester Public Library and the Westchester Township History Museum in Chesterton, Indiana, in search of clues to unlock the mystery of Alice Gray's retreat to a secluded life in the Indiana dunes.

Janet Edwards is the only one of all those writers who has been able to overcome the frustrations of the search for Diana. In so doing, she has breathed new life into the story of a woman born before her time; a woman we can identify with and yet still not fully understand.

Janet's book is the result of more than ten years of meticulous research. She has read hundreds of dusty, crumbling newspaper articles; interviewed those who remembered meeting Alice or hearing family stories about her; and unearthed a wealth of primary resources relating to Alice and her family.

Sifting facts from the fiction, falsehood and legend that were Alice's legacy, Janet has produced the first authoritative and fully documented biography of Alice Gray ever written. It answers questions about her life that have puzzled historians since her death and lays to rest misinformation that continues to circulate about her.

It has been our privilege to open our archives to Janet Edwards. We have been impressed with the dedication she has brought to her search for the real woman behind the Diana of the Dunes myth and with her insights into the life of Alice Gray. We are indeed proud to have played a small part in the

FOREWORD

creation of this timely and important book and enthusiastically recommend it to the reading public.

Eva Hopkins, researcher
Jane Walsh-Brown, curator
Westchester Township History Museum, an educational service of
Westchester Public Library
Chesterton, Indiana
http://www.wpl.lib.in.us/museum

Acknowledgements

An amazing amount of collaboration and collective wisdom helped fill the pages of this book. In the ten years spent researching and writing it, I've met and worked with wonderful people who generously shared their knowledge, time and support. I cannot thank them enough, but I plan to keep at it.

First and foremost, I remember my grandmother, the late Gertrude Mary Cox, who, along with her husband, the Reverend Clinton C. Cox, bought property on Porter Beach in Porter, Indiana, in the heart of dunes country. That was during the 1950s, when they lived in Chicago. Because Grandma Cox fell in love with the dunes, I've been privileged to spend my summers in a cottage filled with family and friends, standing on the beach and marveling at the same glorious horizon as Alice Gray, traipsing through the woods and cherishing both the beauty and power of Lake Michigan. It is an extraordinary and wonderful legacy that Grandma Cox left to my family.

Much love and thanks to my parents for their participation in this project. The book idea would not have achieved traction without significant help from Beverly Zenke, my mother. The research effort was kept afloat by her endless encouragement, expertise in the world of genealogy and incredible tenacity. Many times, when I thought we'd hit the proverbial "brick wall" of documentation, she charged right through it. We supplanted e-mails about family news with e-mails about Alice and her family (my favorite subject header: "GUESS WHAT!!"). When my mother e-mailed late one night to tell me she had goose bumps from the day's excitement of holding

Acknowledgements

documents with original Gray-family handwriting, I knew our hearts were traveling together in the same (long-ago) place.

Ronald Zenke, my father, is also to be commended—for his constant love and encouragement, no matter what I endeavor, but especially for chauffeuring his wife back and forth to the National Archives and other library facilities rich with research about Alice and about our own family.

Eva Hopkins, historian and researcher extraordinaire at the Westchester Township History Museum, is a veritable font of local knowledge—not to mention an excellent sleuth. Whether it's people, photographs, maps, locations, dates, websites or little-known, yet valuable, historical resources, Eva connects the dots in a way that no one else can. She is patient, willing to go off on research tangents for the fun of it, eager to help and seemingly available twenty-four-seven. Toward the end of this project, our after-hours e-mail exchanges kept me writing and digging for yet another vein of truth.

Likewise, Jane Walsh-Brown, curator of the Westchester Township History Museum, has been a great research help and fine editor. Eva and Jane, with fellow museum staff members Joan Costello (another excellent editor) and LuAnne DePriest, are, in fact, an Olympic history team. I urge you to visit the museum; they curate wonderful exhibits on a wide range of regional history topics, in between answering questions from a steady stream of researchers.

Steve McShane, archivist and curator for the Calumet Regional Archives at Indiana University Northwest Library, has provided much-needed insight about researching and has supplied valuable resources over the years.

The reference sections of various libraries were always helpful, and I regret that I did not collect the names of those I'd wish to thank personally. I am especially fond of the following Indiana libraries: Westchester Public Library in Chesterton, Lake County Public Library in Merrillville, Michigan City Public Library in Michigan City and Valparaiso Public Library in Valparaiso. In Chicago, I've enjoyed getting lost in research at the Harold Washington Library Center, the Joseph Regenstein Library at the University of Chicago and the Chicago History Museum (formerly the Chicago Historical Society). For those of you who worked the reference desks at the aforementioned libraries sometime between 2000 and now, I am indebted to your help in learning how to work microfiche machines, tracking down research sources and asking direct questions. The information you provided via e-mail, telephone and in person is greatly appreciated.

I only recently discovered the published diary excerpts of Alice Gray while researching at the Herman B. Wells Library at Indiana University

Acknowledgements

in Bloomington. I was grateful for the weekend hours and the surprising availability of newspaper archives from Chicago. (I wish more libraries crossed such intimate state borders.)

From the beginning, Peter Youngman, historian of Ogden Dunes, Diana of the Dunes and many other interesting subjects, has generously shared his views and research. Author Dave Dempsey also kindly shared his research.

Merri Sue Carter, astronomer with the United States Naval Observatory (USNO), author and historian, provided wonderful information about Alice's time spent working as a "computer" in government employ. Gregory Shelton of the USNO library was also gracious in his assistance.

Catherine Rankovic, an inspired writer and poet, provided excellent writing lessons and meticulous editing.

Thanks also to Joe Gartrell, commissioning editor of The History Press, whose enthusiasm for this book was essential and delightful.

Marion LaRocco, Alice Gray's great-niece, was kind enough to share family stories and open old family photo albums. I greatly appreciate her willingness to share such gems.

The late Dorothy Furness Dunn was a relative of Alice Gray's by marriage and nearly a lifelong resident of Furnessville. Alice's sister was Leonora Gray, who married Ernest Dunn, the grandfather of Dorothy's husband, Robert Dunn. While she came to Alice's story knowing little about her, Dorothy was always willing to help make introductions and pass along research leads. She was supremely proud of her family connection and would have enjoyed sharing Alice's "true" story with others. I regret that she did not have the opportunity.

The late Irene Nelson, who was born in Baillytown in 1909 and was a lifelong resident of what is now Chesterton, is the only person I've met who actually "knew" Alice Gray. Irene was ninety-two years old at the time we spoke. During our visits, she told her stories carefully and with great respect for the people of her past. I will always be grateful for the anecdotes she shared; such treasures are so rare in this case.

I'm also thankful for my telephone conversations with Dr. Richard Whitney, who, as a young boy with a vivid imagination, spent summers in the Indiana sand hills during the time of Diana of the Dunes. His childhood perspective of her myth adds a soft and playful element that contrasts charmingly with the loud and often insensitive newspaper stories about her.

One numbingly cold, windy, steel gray day in February several years ago, I tromped around Oak Hill Cemetery in Gary, Indiana, with my longtime friend, Sarah Wortman, looking for the grave of Alice Gray. We arrived

Acknowledgements

toward dusk, so we were short on daylight; the temperature continued to drop. Quickly, we became frozen and frustrated. Just as we decided to call off the search and start back toward the car, I stepped on Alice's gravestone. For all that I was thinking and feeling in that moment, it was richer because Sarah was with me. She has shared many important moments in my life, and I thank her for sticking close.

For their endless encouragement, genuine interest in Alice's story and eloquent defense of my long years of research as time well spent, I owe a special gratitude to my wonderful friends Deborah Peterson, Terri Walters and Holly Phelan Johnson. My family and friends in the Indiana dunes have heard me talk about Diana of the Dunes for years. For them, especially, I'm pleased that this book is finally in print; maybe now I'll talk about other things, too. Many thanks for listening to my siblings, Sheri, Eric and Chip Zenke; my cousins, Kim and Randy Pavlock, Hilary Frey and Meredith Glick, and to my niece, Cadie Culp, and my nephew, Cameron Culp. Also, I am much obliged to Carrie Curran and her wonderfully large group of sisters, daughters, menfolk and neighbors; Craig Berg; Donna Brown; Alex Struk, Vera Struk and Myra Struk; and the Stager clan.

Jamie Hogan is a Porter Beach resident and local history devotee. Perhaps serendipitously we became friends just in time for her to provide eleventh-hour encouragement, insight and refreshment. I'm grateful for her help in getting to the finish line and for introducing me to so many wonderful people of the dunes.

I'd also like to thank the Friday Night Club, especially Tracy Webb and Geri Lynn Dowdy; Tracy, for her plan to organize me and for her tremendous encouragement, and Geri Lynn, for her great listening skills and for checking on my well-being—especially in the final few months.

Others who have kept inspired me along the way include members of Book Club, Dyan Ortbal-Avalos and my good friends at Maryville University.

I have also enjoyed discussing Alice's story with the friends of my children, most notably Jenny Balzer, Katie Dowdy, Liz Peterson, Natalie Ballsrud, Handley Phelan and Allison Walter. Your questions and interest were always appreciated.

And finally, much love to my husband, Bill, and to our children, David, Sarah and Anna. Years ago, they accepted that I would leave St. Louis for long weekends—often with little warning—to conduct research in the Indiana dunes and Chicago areas; and that while they were sailing Lake Michigan, crinoid hunting and painting stones, I would disappear in search of another library. I'm shamelessly proud of my children's independence,

Acknowledgements

and on some secret level, I give Alice Gray a lot of credit for that. In any case, without my family's tremendous love and support this book would still be scattered in library file cabinets. I greatly appreciate their interest in the story of Alice Gray; that they cheered even minor research successes along the way was a wonderful gift and so fun.

If more photographs and local stories about Alice Gray—Diana of the Dunes—surface because of this book; if the next generation continues to tell her story; and if greater appreciation for the Indiana dunes region is fostered, then all the knowledge, collaboration and encouragement I've received from the wonderful folks mentioned here is made even more valuable.

Introduction

> *The country is of immeasurable value to botanists, ornithologists, and investigators in other fields of natural science.*[1]
> —Earl H. Reed

As befits any place of natural wonder and historic stature, the Indiana dunes region has a favorite folktale that serves to enrich and preserve its past, reveal local mystery and explore universal kinships. In this case, the story is that of Alice Mabel Gray, more popularly known as Diana of the Dunes.

For the past ninety-five years, the legend of Diana of the Dunes has grown as wild as the environs in which she lived. Beginning at Lake Michigan's southern rim and moving inland, long, open stretches of sand hills are bound by a backcountry of tall dunes, dense forest and civilization. Although nearby towns are now sprawling, more easily accessible and much busier, they were once small enclaves of farms and homesteads, connected despite their distance by commerce and family ties. Before 1900, most people considered the dunes largely uninhabitable; the press often referred to it as "trackless wasteland," unexplored and loosely claimed, with vestiges of the early French fur trade and Pottawatomie Indians still traceable along pathways and through first-generation storytelling.

By the turn of the century, however, the steel industry had moved into the area. At the same time, neighboring Chicagoans—led in large part by University of Chicago academics and Chicago Renaissance icons—began in

Introduction

earnest to study, appreciate and celebrate its unusual diversity of botanical life and terrain. The unspoiled beaches attracted growing numbers of recreation seekers. Inevitably, these groups clashed over how best to utilize dunes resources.

Unrelated, yet caught in the same net, the sensational story of Alice Gray rose amid the crashing waves of controversy. She proved a timely metaphor for the struggle to preserve the area's natural heritage amid the unfolding progress of civilization.

Tales about Diana of the Dunes are still told throughout Indiana—especially in the Calumet region. The story usually begins in late fall of 1915, when Alice Mabel Gray stepped onto an old path in the dunes and followed it to the edge of Lake Michigan. She found permanent shelter in an abandoned shack near a sandy ridge, turning her back on Chicago and all the incumbent responsibilities of living and working in the city. Local townspeople were aghast; but just the same, the mystery of her presence was a thrilling interlude that would fuel local gossip for decades to come.

Alice, intelligent and free-spirited, had responded drastically to society's rigid conventions: she excused herself completely from its rules and routine. At age thirty-four, this Phi Beta Kappa graduate of the University of Chicago traded her single, working woman's life for a rougher, yet more thoughtful, existence in the untamed dunes of Indiana, some forty-five miles southeast of the city. From the doorway of the shack she claimed as her own, Alice fearlessly guarded her privacy and her right to live in the sand hills—alone. Her audacity bewitched and befuddled enough eager reporters that Alice quickly became an enigma, a prime target for front-page news in an era of sensational headlines; she grew legendary in her own time. Even so, you will not find many today who recognize the name Alice Gray. Mention Diana of the Dunes, however, and it becomes quite another story.

The Indiana dunes region has long been a place for sojourners desiring escape, nourishment through introspection or a richer, more deliberate experience among the bounties of nature. Alice merely joined the ranks of those who sought sanctuary there, though for others at the time this usually meant weekend retreats; the clamor for year-round living would come later. For myriad reasons, and perhaps no reason in particular, her story became more pressing than that of any other intrepid dunes character. Other inhabitants were mostly forgotten old men, those with fizzled lives who found the life of a hermit more than satisfying. Although historian Earl H. Reed tramped among the dunes to interview them and capture their stories and dialect in books, none of these characters experienced the intense

Introduction

scrutiny that Alice suffered at the typewriters of so many prolific reporters. When they weren't calling her a goddess, they treated her like a sideshow performer, a mystifying and curious misfit. Based largely on details provided in the earliest newspaper accounts, Alice has since become the subject of history-book chapters, newsletter and magazine articles, plays, poems, songs and an art show. The names of local businesses, a town festival, a street, vacation homes—even the naming of a sand dune[2]—have paid homage to Diana of the Dunes. Ghost stories, each with invented details and all claiming reports of Diana "sightings," are published in print and online.

Although given other nicknames by reporters and townspeople—for example, Nymph O' the Dunes—Diana of the Dunes instantly took hold when it was suggested by a Chicago newspaper in the days just after her discovery. Alice might even have considered it a compliment, if not for the notoriety it attracted. Headlines rarely featured her given name. Diana of the Dunes, on the other hand, frequently found its way into bold type. In preliminary searches, it seemed a Chicago journalist first called her Diana of the Dunes. A November 1916 newspaper headline blared, "'Nymph' Alice Now a 'Diana'"; below it, in the article's second paragraph, she was compared to mythological Diana, the Roman huntress. The writer noted that she was a better shot with her rifle than most local men—especially when it came to duck hunting. "This strange woman is recognized here as a veritable Diana. Nimrods who returned with one lone duck as a result of a hunt in the dune observed with envy a score on the line at Miss Alice's windowless cabin."[3]

In fact, an Indiana newspaper originated the nickname Diana of the Dunes in a headline during the first week of her discovery; the headline ran above a story that was reprinted from a Chicago newspaper that, for all practical purposes, may be lost to history.[4] In any case, the name Diana immediately took hold, proclaiming Alice's new, and lasting, identity. As if to be certain, modern-day supporters inscribed "Diana of the Dunes" on Alice's headstone—above "Alice Gray Wilson." The stone was laid many years after her death.

Alice came by the last name of Wilson in the last few years of her life, during which she lived with a man who called himself Paul Wilson. His given name was Paul Eisenblatter; it is unclear why or when he adopted the alias, but he used it consistently both throughout the time he knew Alice and ever afterward. The couple first claimed to be married but later acknowledged they were not. A search of legal records verifies the latter, though there is a lingering question as to the possibility of common-law marriage. As an indication that the nickname Diana had permeated Alice's life, in every

Introduction

news story that quoted Paul he referred to her as Diana—not Alice. Paul had clearly adopted the nickname and likely used it with Alice's blessing.

In an early interview, granted nine months after Alice's arrival in the sand hills, a Chicago reporter quoted Alice as saying that the life of a wage earner in the city was akin to "slavery."[5] To escape the inequality and incivility of the work world and probably, too, to escape a difficult love relationship in the city, she sought a solitary life in the Indiana dunes—her inspiration derived from a poem by Lord Byron titled "Childe Harold's Pilgrimage," in which he wrote the line, "In solitude, where we are least alone." Many have assumed that Alice never achieved such serene seclusion.

During her years in the Indiana dunes—the final ten years of her life—neighbors and reporters alike took copious and creative notes, assigning traits and activities to Alice, both true and false, which are still reflected in prevailing stories. The most popular is that she bathed naked in Lake Michigan (as soon as the ice began breaking up, so some of her contemporaries reported, although Alice denied this) and did so often, running a length of beach to dry her body. Other familiar details: Alice, with weathered skin and a rather indistinct frame, seriously studied dunes flora, read voraciously and wrote manuscripts that she kept private; some of her writings were later stolen, others lost to time—a partial diary survives and is appended. She fished and bought salt, bread and other staples in town. Suspected of stealing food and blankets when times were hard, people also said she borrowed sturdier shelter from vacationers who owned property in the dunes while those owners were away. She walked endlessly, dressed simply in makeshift skirts or khaki pants, talked softly and boldly quoted poetry to intruding reporters. Alice displayed a congenial manner in good company—a fiery venom when threatened. Infrequent visitors sat outside her first patchwork shack, which she named Driftwood, and never glimpsed the interior.

In her second shanty home, Wren's Nest, Alice lived with Wilson, the man who had changed his name and invented most of his past; a man who would cast murder, thievery and injury into Alice's life. On the other hand, he offered security, companionship, adventure, a strong back and—some may doubt this—love.

Various "facts" about Alice are diluted, misconstrued or contrived. Newspaper stories published during her residence in the dunes provide the only original, although not always truthful, accounts of her life. In later years, many more articles followed, but those newspaper stories generated little, if any, new information. No serious research intended as a biographical

Introduction

sketch of Alice Gray is yet in print. This is not to say such research has not been undertaken. On the contrary, local librarians are quick to point out that Diana of the Dunes is a favorite research subject at the reference desk. Library folders all along Lake Michigan's southern shores, from Chicago throughout northwest Indiana, are either bulging with news clippings, oral histories, unattributed notes and unanswered questions about Diana of the Dunes or pitifully lacking in significant mention—folders named for her but nearly empty. There is no comprehensive source; her story stretches as widely as the Indiana dunes themselves and is equally complex. Available details are often second- or third-hand information. Careful scrutiny reveals misinformation in even the most reliable of sources.

Seeded by those early reporters, Alice's tale rooted quickly and deeply in regional history, blossoming as legends do. Even today, her story continues to sprout wild, hybrid shoots of both truth and rumor. For nearly a century, Diana of the Dunes stories have endured through ongoing spates of interpretive hearsay and creative storytelling.

However, what is lost in historical translation is worth recovering here, because in the story of Alice Gray the truth can hold its own against any fabrication. Tales of Diana of the Dunes, and the authentic story of Alice Gray, are timeless, provocative and inspiring. Since newly uncovered facts are in hand, it is time to set straight—as much as possible—the story of Alice Gray.

The legend of Diana of the Dunes still leaves much to the imagination, which contributes to its long-standing popularity. Even after years of focused research, important gaps of time and circumstance are yet unexplained, underlying motives remain muddy and photographs fade in long-forgotten albums. It is hoped that this book will cause new information to rise to the surface, especially in regard to old photographs of Alice. The few images we do have are poor quality copies because the originals are lost, or—like the one featured on the front cover of this book—they are something of a misrepresentation; she was hardly the type to dress up, but while the outfit is an anomaly, the photograph provides the clearest portrait of Alice.

In any case, Diana of the Dunes is bound to continue drifting through the currents of local lore. Without fail, and as it should be, each generation yields new storytellers and new listeners to reaffirm the timelessness of Alice Gray's remarkable story.

Ghost Story:
Diana of the Dunes

Most people first hear about Diana of the Dunes through some variation of a ghost story. The ghost story presented here is adapted from several versions printed in books and online. In telling these tales, the popular mythology about Diana of the Dunes is perpetuated, but most of the facts regarding Alice Gray's life are either exaggerated or completely fabricated. In the chapters following, such distortions are revealed and set right, as much as possible.

A woman dressed in a long, flowing, white gown is often seen at night, drifting through the pine trees at the top of a sand ridge or floating just above the surface of Lake Michigan at water's edge—but then she quickly disappears. The shadowy figure is thought to be the ghost of Diana of the Dunes, a woman who lived long ago in the Indiana sand hills.

Diana of the Dunes was discovered in the summer of 1916, when a lone fisherman trolling along the Indiana shore of Lake Michigan spied a young, beautiful woman splashing naked through the waves. After swimming, she danced like a nymph on the beach to dry off. Startled and aflutter, the angler told his wife, who shared the gossip with friends and neighbors. The story traveled swiftly through the region. Soon other fishermen, their curiosity piqued about the mermaid, began to drop their lines along the shore near her shack hoping to see the mystical creature. Newspaper reporters ventured from Chicago to pounce on the story. They called her Diana of the Dunes, a strange hermit girl who lived in an abandoned fisherman's shack and spoke to no one.

Diana of the Dunes was, in fact, Alice Mabel Gray, the daughter of a successful Chicago physician. She was well educated, cultured and had

traveled the world, but she chose to live by herself in the dunes, an area she had often visited as a child.

What mysterious circumstance propelled her to lead such a lonely life? It was rumored that she ran to the wilderness of the dunes to escape a tragic love affair. But the harder she fought for her privacy, the more reporters hounded her.

Along the way, Diana married Paul Wilson, who was a giant of a man. He had a reputation as a rough drifter and a petty thief. When a grisly murder took place near their shack, Paul was the prime suspect, but his guilt was never proved.

Paul often treated Diana badly. She died in 1925 from uremia, brought on by stomach injuries later found to be the result of a beating at his hand, just after she had given birth to their second daughter.

Before she died, Diana asked Paul to cremate her body and cast her ashes to the north wind from Mount Tom, the tallest dune in the region. He refused, and she was buried in a potter's field in Gary, Indiana.

Paul was later shot trying to escape from a California prison, where he was serving a sentence for auto theft.

Did Diana ever find the solitude she sought? Maybe not while she was living, but perhaps in death Diana is finally able to wander peacefully among her beloved dunes.

Chicago Childhood

One of the more important of these was the Beers family who located here after leaving their native New England. They were, in fact, part of that important migration of Yankees to Chicago which had so much influence on the cultural and economic life of the early city. [6]
—Chicago: City of Neighborhoods

The 1880s through early 1900s was an exciting and volatile time in the history of Chicago. One of the nation's largest metropolitan regions, a burgeoning Chicago then ran second only to New York in population. Marked by bold infrastructure progress and landmark efforts to advance social justice, the turn-of-the-century years featured rapid-fire events and banner headlines.

Southwest of the city, a working-class community was just becoming established. In its earliest days, what is now the McKinley Park neighborhood was once, briefly, called Canalport. The locale's terrain was primarily prairie and swamps. When most of the area was annexed by Chicago in 1863, however, developers awoke to its potential.

Even so, the most dramatic growth for the community occurred after the infamous Chicago fire of 1871. Factories and steel mills, twenty-seven brickyards, real estate companies and immigrants poured into the area. Block after block of "workmen's cottages" popped up, the houses closely situated and lined up like dutiful sentinels. A historic survey noted "ready jobs in these local factories encouraged continued residential growth. North of 35th,

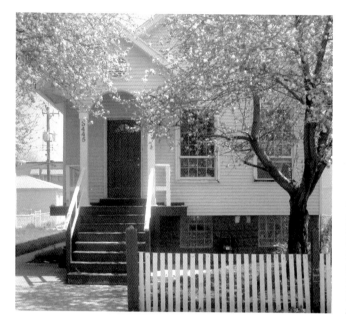

A modern-day photograph of the house where Alice Gray and her family lived. The house is located in what is now McKinley Park. *Courtesy of Josh Mendoza.*

land was subdivided and platted for cottages much like the one remaining at 3445 S. Hermitage."[7]

In that particular house, 3445 South Hermitage (although the street was then called Bloom), Alice Mabel Gray—who would one day become known as Diana of the Dunes—was born on March 25, 1881, the fifth of six children.[8] Her parents were Ambrose and Sallie Gray. Alice's sisters, Leonora and Nannie, were much older than Alice—fourteen and eleven—while her brothers, Hugh and Harry, were nine and four. The youngest Gray child, Chester, was born three weeks before Alice's second birthday.

Following the lead of other family members who had migrated earlier from Fairfield, Connecticut, the Grays moved to the Chicago region in 1873, arriving just two years after the Chicago fire. They came from Bean Blossom, in Brown County, Indiana. Alice's uncle, Samuel Beers, married Emily Gray, sister of Ambrose. He paid for the Grays' new, single-story home. At least for a few years, until the older girls were married, the small, frame house—measuring less than one thousand square feet—must have been quite busy with six children underfoot.

Beers continued to own it until 1900, when he sold it to Sarah Gray, a second sister of Ambrose (she sold it out of the family seventeen years later).

The True Story of Alice Gray

THE николайNeighborhood

During the thirty years the Grays occupied this address, the community was tightly woven. Doctors, relatives, future relatives and neighbors—some of whom later appear as official witnesses to Gray family documents and petitions—all lived or worked within a few blocks. Along with Alice's extended family, large numbers of Germans, Irish, Swedes, English and other ethnic groups settled the area.

Samuel Beers was one of four Beers brothers, at least two of whom lived within a block or two of the Grays. According to the Beers's family records, in the mid-1800s, their father, Simeon Beers, purchased five hundred acres of land in south Chicago and established a cattle ranch and farm. McKinley Park historians claim he sold the property for housing developments; family genealogists say the property sold for expansion of the stockyards. Given the acreage and the proximity of the meatpacking industry to employee housing, it may well have become both business and residential property.

In any case, local historians honor the Beers family as founders of McKinley Park.

Alice's neighborhood closely bordered Chicago's Back of the Yards and Bridgeport areas, where stockyards and meat packaging sites stretched for city blocks on end. The stench from the stockyards, which began permeating daily life fifteen years before Alice was born, proved a constant annoyance to those who lived anywhere near it. The Illinois Labor History Society describes the adjacent industry this way:

> *On the South Side of Chicago, from 39th Street to 47th Street, and from Halsted to Ashland Ave., was the largest livestock market and meat processing center in the world. Approximately one mile square, it served the nation's great meat packing companies and many smaller ones located in the surrounding area. The "stockyards smell," which the breezes spread for many miles into residential areas, near and far, could be obnoxious; but people said the smell meant work.*[9]

The stockyards produced hazardous living conditions for myriad reasons, but one in particular ran along the eastern boundary of Alice's neighborhood. A southern branch of the Chicago River became a dumping ground—an open sewer—for waste from the stockyards and other local industries, including steel foundries and brickyards. It earned a legendary

reputation as Bubbly Creek due to spontaneous, gaseous eruptions from the thick, murky water.

In the decade leading up to 1900, the streets of Alice's neighborhood, which had been dirt, were packed down with rock, and sewers were installed.

McKinley Park earned its name following the dedication of a new park that debuted in 1901. It was named for President William McKinley, who was assassinated just before it opened.

Schools

Both families, the Beerses and the Grays, originated in Fairfield, Connecticut. They continued to live near each other in Chicago, which meant the young cousins attended grammar and high schools together. Indications are that none of Alice's sisters or brothers furthered their studies at the university level, although at least one of her female cousins, Lila E. Beers, graduated from Vassar College and medical school. She was the daughter of Samuel Beers.

Alice likely spent her grammar-school years at Brighton (later renamed Longfellow) School, located at the corner of West Thirty-fifth and

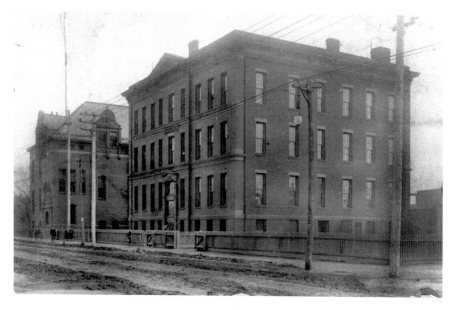

A postcard of Longfellow School, formerly named Brighton, where it is believed Alice Gray attended grammar school in Chicago. The McKinley Park Branch of the Chicago Public Library now sits on the property. *Courtesy of the author.*

The True Story of Alice Gray

Winchester Streets. Built in 1880, it is considered one of Chicago's oldest public schools. Mentions of Alice's later, voracious penchant for reading and borrowing library books are consistent throughout her dunes history. In that case, it seems fitting that after long and repeated demands from the modern community, a McKinley Park Branch of the Chicago Public Library finally opened in 1995 on the site where Alice's former grammar school once stood; the school was razed to make way for the new facility.

Historical proceedings of the Chicago Board of Education document Alice's 1897 graduation from South Division High School, then located at Twenty-sixth Street and Wabash Avenue, eight blocks from her house. South Division tended toward liberal educational philosophies, with an emphasis on classical studies. Perhaps this is where Alice first discovered her love of reading and her admiration for Lord Byron's poetry, her curiosity about the starry heavens and her ability to work through challenging mathematical problems. All played key roles in her later life. Three years after Alice's graduation, the high school celebrated its twenty-fifth anniversary. An article in the *Chicago Tribune* touted South Division's "remarkable" history, noting its status as the second-oldest high school in the city. "Many of Chicago's most prominent citizens and celebrated men have been graduated from this school.... The history of the South Division high school lies parallel with the progress and growth of Chicago since its rejuvenation in the early '70s."[10]

The school prided itself on allowing students to work at their own pace and focus on particular subject areas:

> *From a rigid and prescribed course of study formerly laid down for all students it has now adopted a system which permits the students to choose certain courses of study and to specialize in these alone....Mr. Jeremiah Slocum, the school's first principal...is well known throughout the entire West as an educator of advanced liberal views.* [11]

Records from this early period could not be found in Chicago Public Schools archives at the time of this writing, so Alice's particular studies or extracurricular activities during her high school years are unknown. However, it appears she was among the most successful students. During the 1895 graduation ceremonies, two years before Alice's own, she received one of two Victor F. Lawson medals awarded for academic excellence.[12]

At the age of sixteen, Alice graduated from South Division High School[13] on June 24, 1897, in a ceremony held at Sinai Temple on Indiana Avenue and Twenty-first Street. She was the youngest in a class of ninety students.

Among her fellow graduates was her cousin, Sylvester Beers. During the graduation proceedings, just one student addressed the audience—Alice M. Gray, who read an essay titled "The Old Teutonic Home." The keynote address was given by Dr. S.J. McPherson of the Second Presbyterian Church, who spoke on "The School, the Home and the Country."[14]

After graduation, Alice enrolled at the University of Chicago for the following fall semester. She was destined for a long association with the university.

Childhood View of Chicago

Although she may have been oblivious by virtue of her age, Alice was a young child when the nation's first skyscraper rose up in the heart of Chicago and when the infamous Haymarket Riot, a protest for workers' rights, resulted in the deaths of eight police officers. She was eight years old when activist Jane Addams opened Hull House, a pioneering settlement facility serving Chicago's growing community of immigrants.

The 1893 Chicago Columbian Exposition invigorated the population. The six-month world festival graced Jackson Park and the Midway Plaisance, stretching across six-hundred-plus acres of land near Lake Michigan. The Gray family lived about six miles south of the festival, but transit then was cumbersome. As millions of people from all over the world filtered through its gates, Alice, eleven years old, might have been among them, paying a child's fare of twenty-five cents. Perhaps she rode the world's first Ferris wheel and other carnival rides or meandered through the replica Street in Cairo to admire the souvenirs. She might have been amazed by the breathtaking display of electricity—yet uncommon in Chicago—and enjoyed Buffalo Bill's Wild West Show, a popular encampment on an out-parcel near the official fairgrounds.

Despite its proximity, Alice likely did not visit the fair often, however. Hers was a working-class family, one that could not afford to own its home. In fact, circumstances would cause her father, Ambrose, to struggle financially until the day he died.

Ambrose and Sallie Gray

Just think, dear. I have never had a friend, except my mother, who died thirteen years ago. [15]
—Alice Gray

Although most accounts of Alice's family describe her father, Ambrose Gray, as a successful physician, he simply was not. This refutes, among other misconceptions, the notion that the Gray family was wealthy and that Alice left behind a privileged background when she settled in the Indiana sand hills. The mistake likely occurred decades ago when someone checked the Chicago directories and noted the listing of a physician by the name of Allen Gray. Because reporters harped on her impressive education and refined manner, the first researchers may have concluded Alice's father was this Allen Gray, not "A." Gray, the resident listed as a "laborer."

In fact, the Grays lived on a sparse income. A tragic accident befell Ambrose when Alice was fourteen years old. The episode created additional economic hardships for the family.

Ambrose Beardsley Gray was born in 1842, in Fairfield, Connecticut, where he lived until he left home to seek his own fortune. Because it would plague him the rest of his life, one particular story survives from Ambrose's childhood. In later years, he would relate this incident to a U.S. Pension Board medical examiner: "My eye and ear were hurt. When I was a boy, a log of wood rolled over me....On my left eye I see every object double. This eye is now no good to me at all."[16]

He also suffered permanent, partial deafness resulting from the same accident.

As a young man, Ambrose was an early settler of Brown County, Indiana. He had served as an apprentice to a spectacles maker in Connecticut and followed his employer, George Staples, to Indiana to establish a new factory.

In 1865, at the age of twenty-four, Ambrose enlisted in the Civil War in Columbus, Indiana, identifying his occupation as a "spectacle maker" in Bean Blossom, Indiana. The enlistment record describes him as dark-haired and standing five feet, eight inches; he had hazel-colored eyes and a dark complexion.

Gray became a private in Company E of the 145th Indiana Regiment. His Union regiment first guarded the railroad in Dalton, Georgia, and then was assigned to Marietta, Georgia. In the fall of 1865, it was ordered to Cuthbert, Georgia. Having served the final year of the Civil War, this group of soldiers mustered out at Macon, Georgia, in January of 1866.[17]

Four months after he returned to Indiana, Gray married Sallie Gray. (Gray was also her maiden name, which provided some early, puzzling hurdles during genealogical searches.) Sallie was born in Indiana in 1844, although her parents originally came from North Carolina.

The couple married April 4, 1866, in Brown County. Three children—Leonora, Nannie and Hugh—were born in this first home. The family moved to Chicago in July of 1873.[18]

When the Grays first settled in the city, Chicago directories listed Ambrose as an ironworker and later as a laborer; the specifics of these jobs are unknown. At some point, he began work as a lamplighter, this in an era when thousands of gas lamps still spanned the streets of Chicago. His beat included Archer Street, just blocks from his home. It was on this stretch of his route that a serious accident occurred, one with severe, long-term consequences.

One late summer afternoon, a disturbing commotion interrupted a druggist while he worked in his store at 3199 Archer Avenue.[19]

The druggist reported the incident this way:

On August 29th, 1895...Ambrose B. Gray, rushed into my store and informed me that he had been filling a street-lamp (as that was his occupation). The lamp leaked and saturated his clothing with gasoline and ignited, burning his left hand, arm and shoulders. He was so badly burned the skin hung in shreds. I immediately applied dressing, pending the arrival of George E. Willard, M.D., who was sent for.[20]

The True Story of Alice Gray

In his own hand, Dr. Willard recorded the story for the U.S. Pension Office:

On the 29th day of August, 1895, I was called to attend said soldier and found him suffering from a very severe burn of the left hand, arm, shoulder, neck and face, (caused, he told me, by the leaking of a gasoline street lamp saturating his clothing and igniting.) The destruction of tissue was so great that he has totally lost the use of the left arm and hand. He also received such a severe nervous shock as the result of the accident that he was confined to his bed for one year from the date of the receipt of the injury, since which time he has been continuously under my care, I having visited him at his home during his year of confinement.

Alice's father spent an entire year unable to leave his bed. Whatever his household duties had been, no doubt many of those tasks fell to Alice and her younger brother, Chester. Their next-oldest sibling, Harry, was already eighteen and likely living on his own, as were the other Gray children. Their father did the only thing he could, given the situation—he filed for yet another military pension increase to help improve the family's income.

Three times in four years prior to his accident, between 1891 and 1894, Ambrose requested an increase in his Civil War pension. He claimed a need based on his impaired sight and chronic diarrhea; the latter, he wrote, resulted during his army stint and caused him to lose "a number of weeks of work" each year. On one of these applications, the examining doctor found him "poorly nourished" and confirmed his other ailments. Yet the government denied every one of his requests for additional payments.

Ambrose sent in paperwork for a fourth request for an increased pension in 1895. That application followed his burn incident. With his emotional capacity waning, Ambrose described his overall condition in stark terms. He told the pension board that the burns caused him "nervous prostration" and declared he was "wholly unable" to earn support for his family. Dr. Willard confirmed the dire circumstances: "Since his ability to walk out he has visited me at my office every 4 or 6 days. And during the time since the 29th day of August 1895 to the present date the loss of time from labor has been total, or 100 %."[21]

During that first year of recuperation, when Ambrose undoubtedly spent many painful, monotonous days confined to his bed, Sallie managed the household's affairs. A friend of Sallie's later wrote, "During his sickness and disability she maintained and kept the family together by hard work, in raising poultry, vegetables, etc."[22]

Ambrose filed his last request for additional pension funds in 1897. He died, at the age of fifty-seven, of cerebral hemorrhage on June 7, 1898, ending three years of suffering from the debilitating, demoralizing effects of his burn injuries.

The family buried its husband and father in Chicago's Oak Woods Cemetery on a hot summer day, thunderstorms threatening overhead. Alice was surely accompanied graveside by her mother, along with uncles, aunts and cousins, many of whom lived in the same neighborhood. Each of Alice's sisters and brothers, except Chester, were living on their own. Her eldest sister, Leonora Dunn, would have traveled with her growing family to the funeral from her home in nearby Michigan City, Indiana. Two other siblings, if they made the trip, came from Iowa. Another brother still lived in the Chicago area, on the same street as his family, one block separating their houses.

Following the death of Ambrose, the family continued to seek additional income. By the time U.S. census workers came around in 1900, Alice (spelled "Allas" on the census) worked as a stenographer, while Chester indicated work as an "office boy." In the meantime, Sallie Gray applied to the U.S. Pension Office for an increase of two dollars per month. The process was tiresome; the response less than satisfying. On multiple affidavits for the pension board following Ambrose's death, Sallie detailed her meager living. Neither she nor her husband owned real estate. They held no stocks, no bonds and no other investments.

Among the disclaimers, she wrote, "I obtain my livelihood by the board of one man and keep about twenty hens, and have a garden plat of about 20 x 40 feet, where I raise a few summer vegetables for my own use."

As if the process were not humbling enough, Sallie felt compelled to add this note at the end of one notarized affidavit: "There is no taxable property in my name and as Samuel Beers owns the property where I live he sends herewith his affidavit that I own no property as the clerk refuses to make affidavit as it takes too much of his time to hunt up the records."

Chicago neighbors, as well as several from Sallie's childhood home in Indiana, sent statements to the pension office attesting to her marriage and in witness to the truth of her claims.

The pension board again denied the family's request for an increase in the monthly stipend. "Rejection on the ground that there is no period for which increase of pension can be allowed, the solider having died without medical examination under application filed April 28, 1897."[23]

Along with other records, the original marriage license of Ambrose and Sallie Gray is on file at the National Archives in Washington, D.C. The U.S.

The True Story of Alice Gray

Pension Office required the document to prove the couple's marriage, ensuring that Sallie would continue to receive pension payments for herself, Chester and Alice. When Sallie died, Alice, who was named Chester's legal guardian, continued to receive this benefit for one year, until her brother came of age.

In that last year, the U.S. Pension Office finally saw fit to allow an additional stipend, raising the pension benefit from six to eight dollars.

In February of 1902, during her fourth year at the university and in as many years after burying her father, Alice once again stood inside the gates of Oak Woods Cemetery, this time to sign papers for the interment of the woman Alice later said was her one true friend—her mother. Sallie Gray, at age fifty-nine, died of pulmonary tuberculosis. The disease was one of the leading causes of death in Chicago at the time.

As had happened with Ambrose, Sallie died on a Thursday. Temperatures hovered near freezing. On the following Saturday, the day of burial, the family gathered to say their farewells under a warmer, sun-filled sky. The Gray children and their families, if they attended, traveled from the same places as they had when Ambrose died; by now, most of them, with the notable exception of Alice (and with the possible exception of an older brother), had firmly settled into their respective cities.

Leonora paid for the graves of both Sallie and Ambrose, according to cemetery records, and—given their location in the cemetery—at a probable cost of two dollars each, the most inexpensive available. Headstones do not mark these graves or those of other family members who died in the years following.

In that case, it should come as no surprise that Alice's family later chose not to mark her grave. Some published stories insist, however, that her grave is unmarked because her family had "disowned" Alice long before her death. Marion LaRocco,[24] Alice's great-niece, has indicated that, on the contrary, Alice's siblings were quite fond of her; they spoke of her so often, in fact, that the husband of a great-niece recorded an audiotape[25] of the stories the family shared about Alice as a child. This woman never knew Alice, so her affection grew from the stories told by her mother and her mother's siblings—Alice's nieces and nephews.

At the age of twenty and on her own in Chicago, Alice moved out of the family home to an address on Lake Street. She must have taken a deep breath and moved quickly to learn the business of caring for herself, at least in time to salvage her education. Her grades, which had slipped during her mother's illness, shot back up to top marks the following semester.

Given her coursework from that point on, it seems that Alice had found her niche—she focused almost exclusively on the study of mathematics.

Phi Beta Kappa

To be human is to be social, to be social is to be historical, judgments, in order to be sound, must be historical. The term "crank" is one we use to characterize that class of individuals who are completely sterilized from the taint of historical-mindedness.[26]
—*Benjamin Ide Wheeler*

Alice enrolled in the University of Chicago just six years after the school opened its doors. Given the income level of her family at the time, it seems unlikely her parents paid for her tuition, which was forty dollars per quarter. Several alternatives seem plausible, but, either way, a determined Alice enrolled in both undergraduate and graduate studies over a period of fifteen years.

An obituary for Alice, published in the *New York Times*,[27] is rife with interesting, but unverified, information. The notice claims that Alice attended the University of Chicago on a scholarship passed on to her by Sarah Adler, a fellow classmate and wealthy friend who earned it but was not financially in need. University researchers could not confirm the scholarship nor recover Alice's financial records. At age seventeen, Alice was already working as a stenographer and may have paid her own way through school, along with grants or other assistance. Or perhaps her uncle, Samuel Beers, helped pay her tuition costs. It was this uncle who owned her family's house and whose daughter became a general practice doctor.

Alice's academic ambitions might have spawned an early nickname, which later fell away in favor of other, more notorious ones. The *New York Times*

obituary noted that Alice, along with two of her high school classmates, was known as one of the College Class. These young women included the same Sarah Adler and another friend, Grace Nathan. A Sara (no "h" this time) Adler did graduate from South Division High School, although she was one year ahead of Alice, in 1896. However, a student named Grace Nathan does not show up in a list of graduates for either the year Alice graduated or the year after. More intriguingly, the Chicago School Board proceedings show asterisks next to the names of students who took a college preparatory course; neither Alice nor Sara is so noted.

In her undergraduate years, 1897–1903, Alice studied two languages, German and French. Along with introductory and required courses, she focused on theology, astronomy and mathematics—primarily mathematics; her courses ranged from geometry to increasingly advanced calculus and advanced theory classes. She often enrolled in two math courses per semester.

Along with twelve fellow students, Alice was elected to Phi Beta Kappa and initiated on June 17, 1901, during the university's decennial five-day celebration. University of California President Benjamin Ide Wheeler spoke for an hour in his address to the Phi Beta Kappa society. His topic was "Things Human."

Alice's records show an extended scholarly association with Eliakim H. Moore, then the distinguished chair of the University of Chicago mathematics department. It seems no small feat that her classes with Moore were continuous and numerous. At the time, the department was quickly earning a national reputation for advanced research and theorizing. Worldwide, it ranked among the most highly regarded of the day, including German universities easily considered the elite of mathematical study. Moore had a reputation for insisting on only the best, most stringent work from his students and was impatient with those who could not keep up. Under his direction, and that of his handpicked professorial staff, several of Alice's contemporaries later became important mathematicians and educators, including Oswald Veblen, R.L. Moore, T.H. Hildebrandt and George Birkhoff.[28] The school's reputation was renowned:

> *The three leading men in mathematics at the University of Chicago at that time (1898) were E.H. Moore, O. Bolza, and H. Maschke. They supplemented each other beautifully....Under the leadership of these three men Chicago was unsurpassed at that time in America as an institution for the study of higher mathematics.*[29]

The True Story of Alice Gray

Eliakim H. Moore, chair of the mathematics department at the University of Chicago during Alice's years of study. *Courtesy of the American Mathematical Society.*

Thirty-one men and thirty-seven women received diplomas from the University of Chicago on March 17, 1903. During the convocation, the university's mathematics department presented its highest academic honor to one student—Alice Mabel Gray. Along with her AB degree, Alice earned an "Honorable Mention for Excellence in Senior College Work."

The topics addressed by the guest speakers that day seemed to parallel Alice's future endeavors. The Reverend Frank Wakeley Gunsaulus, DD, president of the Armour Institute of Technology, delivered the keynote address, speaking on "The Heroism of Scholarship." Later descriptions of Alice paint her as a reader of classical literature and scientific works and as an avid student of the dunes environment; she also worked prodigiously on manuscripts.

During the graduation ceremony, Jean Jules Jusserand received an honorary doctor of law degree. Jusserand, a French diplomat and author, served at the time as French ambassador to the United States. In 1916, he would win the first Pulitzer Prize in History for his book on United States history.[30] Alice, too, was interested in discovering and recording history,

although her interest was apparently restricted to the dunes region and, in particular, the settlers of the Bailly trading post and homestead.

The new University of Chicago graduates recessed to the parade march *Invincible Eagle*, composed two years earlier by popular ragtime pianist John Philip Sousa.

The University of Chicago yearbook, *The Cap and Gown*, 1903 edition, identifies Alice Gray as a graduate of South Division High School but does not include an undergraduate photo or list her extracurricular activities.

Tracing the mathematics "genealogy" of Alice's professors and fellow students reveals a strong tie to the University of Gottingen in Germany, one of the few universities worldwide that accepted women as equally capable of mathematical study as men (although women could only audit courses before 1908). These connections certainly influenced Alice, who made plans before graduation to further her studies there; her transcripts were sent to the University of Gottingen upon her graduation.

Alice did eventually study in Germany, but first she moved to the nation's capital.

From the USNO to Germany

> *If the monotony of computing was difficult for other bright women, it must have been especially difficult on Alice Gray, for she was, to say the least, a free spirit.*
> —The Contributions of Women to the
> United States Naval Observatory

At the age of twenty-two, seven months after receiving her degree, Alice left Chicago to work in Washington, D.C., at the U.S. Naval Observatory (USNO). For the next two years, she worked as a "computer," one of the earliest group of women hired in this capacity.

To apply for the position, common practice meant taking the Civil Service Examination. Job applicants competed in a standardized hiring system, which did not reference gender at the time of application. The exams were graded, and applicants with the highest scores landed at the top of the hiring list. Successful candidates learned of their acceptance via telegram.

Alice forged ahead with her career despite prevailing societal attitudes about women and work. In 1903, the same year she was hired by the USNO, John T. Doyle, then secretary of the United States Civil Service Commission, had this to say about the future of women in government employ:

> *It is too early to pass judgment on what she can do in competition with men in the higher fields of business endeavor. She needs a generation or two in which to get to her enfranchisement, to practice her untried powers and to rise out of centuries of self-effacement, repression and insufficient*

equipment. She needs time to perfect her gradual approach to man's powers in mental work. She has done well in the ordinary clerical grades.[31]

Doyle noted that women were welcome to apply for a list of particular government jobs, all requiring passage of the Civil Service Exam: piecework, computer (not only for the naval observatory but also in the Nautical Almanac Office), architectural designer, photographic assistant, chemical clerk, department assistant in the Philippines (bookkeeping, finance and chemistry) and "preparator" or "modeler" in the National Museum.

The government, Doyle wrote, could provide women with a golden opportunity to move up in the work world. "In the government service she is finding a career and opportunity for the development of her powers. Uncle Sam, with all his faults, is the best-natured and most generous of employers. He does not cut wages to a starvation basis nor unfeelingly dismiss dependent women like an unscrupulous sweater or contractor."[32]

Alice began her job at the USNO on October 22, 1903. According to employee records, she was "attached to the Division of Meridian Instrument under the direction of William S. Eichelberger for a period of seven months as a computer engaged in general reductions under the direction of the

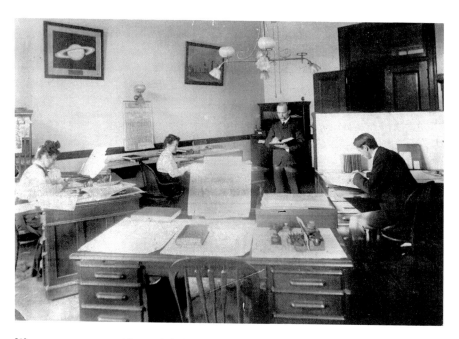

Women computers working at their desks in the main building of the United States Naval Observatory, much as Alice would have done. *Courtesy of the U.S. Navy.*

The True Story of Alice Gray

committee on editing and printing." In this capacity, she might have edited tables of numbers for correctness and looked over page proofs before they were published.

Following this stint, Alice worked as a "miscellaneous computer."

Merri Sue Carter, USNO astronomer and historian, describes the work performed by Alice as "incredibly tedious, monotonous." Computers had second-class status as workers, Carter says; the observatory referenced them as "subprofessionals." Work shifts lasted ten hours per day. Alice spent these hours working on an almanac; she figured routine equations to help chart the location of stars. At the time, hand calculations were the only means to a result. One part of the overall calculation fell to each computer, the same part for each equation. The daily task played out something like this: Alice would work ten steps of a logarithmic equation, pass her calculations on to the next computer and then work the same ten steps again, using new sets of numbers each time.

Alice's pay remained constant during her job term, about $1,200 annually. The pay scale was firm, with little hope of a raise; it was set in 1892, twelve years prior to Alice's hiring.

Most USNO computers were women. Because of strict nepotism rules, all men and women were single or married to people working elsewhere.

Despite their mathematical abilities, female computers could not hope to win more challenging opportunities within the observatory. Several limitations prevented this, Carter notes. Senior positions required a navy commission—which, by law, women could not obtain. Also, admission to scientific societies often depended upon the extent of one's publishing in academic journals, but articles emanating from the observatory staff routinely carried the name of the author's supervisor, rather than crediting the author directly.

Furthermore, because the observatory insisted that all research must directly relate to navy operations, the most exciting and progressive projects landed at the doorsteps of private and university observatories, rather than the USNO.

Carter writes:

> *When evaluating the success of the women employees prior to 1920 one must be aware that the most successful career path at the Observatory at this time required a person to be able to observe with one of the many telescopes on the grounds. However not a single observation at the Naval Observatory was made by a woman until after World War I...there was a general policy of discrimination against women as observers.*[33]

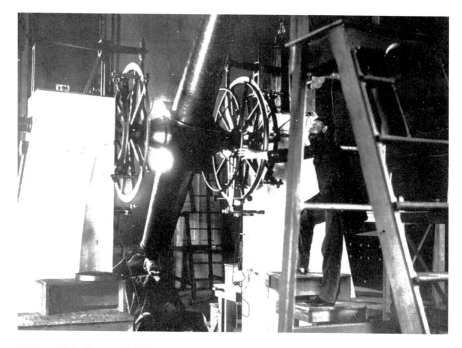

William Eichelberger (right) is shown working on the nine-inch transit telescope in 1901. Alice worked for Eichelberger as a computer at the USNO. *Courtesy of the U.S. Navy.*

Carter points to the oral history of Alfred Mikesell[34] for further clarification: "Women were not allowed to observe because 'It would be immoral for women to be alone amongst the equipment at night,' and 'Women did not have the abilities that would be required to observe nights.'"

Alice lived within walking distance of the USNO. In her first year, she boarded on U Street in a typical red brick row house that still stands. Sometime during the next year, she moved to Wisconsin Avenue, closer to the observatory.

Perhaps by her own design, relatively little of Alice's period of employment at the observatory is documented. No "official" photograph exists in her employee folder, although the files of other women who worked there at the time do include photographs. Observatory computers frequently enjoyed luncheons to celebrate one another's personal news and achievements and to mark anniversaries and holidays. Many snapshots of these luncheons are archived, with all the women clearly identified on the back of each photograph. Alice is not among them; for whatever reason, she completely avoided photographers during her two-year employment.

The True Story of Alice Gray

A notation in Alice's file illustrates her penchant for adopting habits that others found disconcerting for lack of feminine qualities: "Miss Gray...had cut her hair short. She also worked in pants!" By ignoring both proper and stylish appearances of the time, Alice was clearly out to impress people using nothing more than her intelligence.

Carter calls Alice one of the USNO's "best and brightest" and lauds her tenacity for sticking with the job of computer for two very long, very flat years:

> *If the monotony of computing was difficult for other bright women, it must have been especially difficult on Alice Gray, for she was, to say the least, a free spirit. Not much is known of her work here at the Observatory, though she was known to have had an intense interest in astronomy and wanted to pursue her studies in tide research.*[35]

Whether it was boredom, a desire to further her studies or something else that propelled Alice elsewhere is unknown. Perhaps her work at the USNO lasted as long as it did because she was saving money for her next adventure. In any case, her own words, spoken to a friend, indicate that she left the U.S. Naval Observatory bound for study in Germany.[36]

Records show Alice M. Gray was admitted as a "guest-listener" at the prestigious University of Gottingen from the winter semester of 1906 through the summer semester of 1908.[37] The university did not record information about what visiting students studied; furthermore, transcripts of visiting students left the institution when the students did, in their own care. Although there is no official documentation, Alice likely focused on mathematics.[38] In a letter dated years later, Chicago historian Olga Schiemann wrote that Alice had "three years of higher mathematics in Germany."[39] Schiemann had become a friend in whom Alice confided various threads of her personal story.

A few months after classes ended in 1908, Alice left Germany. Identifying herself as a "student," she departed from Liverpool, England, traveling as a second-class passenger on the ship *Kensington*. She arrived back in North America at Quebec's Montreal port on September 28.

By October, Alice had already enrolled in graduate studies at the University of Chicago. Of her three classes, two were mathematics seminars. The third was a "physical culture" (physical education) requirement. During the first eight of the next ten quarters, beginning in the winter of 1909, Alice enrolled in nine mathematics courses, including several seminars. She studied the theory of numbers, algebraic theory and foundations of pure mathematics.

In the winter of 1910, Alice took a lecture class in labor and capital issues, along with mathematics. A year later, she studied elementary Italian and enrolled in a "pure mathematics" seminar. That seminar marked her last class devoted to the study of numbers.

Alice enrolled only in beginning Sanskrit in the summer quarter of 1911; she sat out the fall and winter quarters of 1912. When she registered for classes the following spring, Alice's thoughts were not on mathematics: she was interested in philosophy and signed up for two classes—one focused on Descartes and the other on the "logic of social sciences." Although Alice did not complete the philosophy work, she received an "A" in her third course, a political science class titled "Population & Standard of Living." It was her last course.

After four years of graduate studies, Alice discontinued her education at the University of Chicago. In a diary entry she wrote three years later, she expressed some regret about having made that choice. "If I had had faith and gone on energetically with either mathematics, or logic, or ethics, or literature, or politics, or any combination of two or more of the five, or anything else under the sun, doubtless it would have been well with me."[40]

During her time as a graduate student, many sources suggest she was an editorial secretary for the University of Chicago's *Astrophysical Journal*. (This could not be verified with the University of Chicago.) In another diary excerpt, Alice mentioned editing a book and debated whether she might have edited another one had she stayed in Chicago.[41] It would have been one or both of those two positions that she left behind when she settled in the dunes region. She never worked in an office again.

It is not easy to track Alice during the years after she stopped taking classes and before she moved to the Indiana dunes; she is not listed in Chicago city directories. Her great-niece, Marion LaRocco, shed some light on that difficulty: "At that time, when you rented an apartment you got the first month's rent free. At the end of the month, Alice would move and rent another one."

Leaving Chicago

Sandland at twilight / All hushed in brooding gray— / A place to find your heart again / And cast your cares away. / Duneland at sunrise, / Life's glory risen new— / The arms of freedom flinging wide / The gates your dream saw thru [sic].[42]
—George E. Bowen

When Alice Gray left Chicago on a South Shore electric train in the fall of 1915, she was thirty-four years old and intent on seeking one thing—solitude. She aimed to find it in the remote hollows of the dunes region, which she had no doubt heard about but perhaps visited only in Michigan City, Indiana, where her sister, Leonora, lived with her family.

On a determined mission to disengage from the trappings of work and society, she brought little of her city possessions. The adventure was largely unrehearsed, so she could hardly know what to expect or how to plan for such an unusual new life. Furthermore, she had no idea how long she would be gone from Chicago; at this point, however, she did not plan to stay away for the rest of her life.

Alice was no stranger to the notion of radically shifting direction; she had already done so twice—once when she moved to Washington, D.C., to work at the observatory and again when she set sail for Germany to study mathematics. By the time she stepped off an interurban train at the Wilson stop in Indiana, she had lived on her own for more than a decade. Even so, making a home in the outdoors, temporary or not, required a far different

set of survival skills than working as an editorial secretary or a book editor, the two probable jobs she walked away from on October 31, 1915.[43]

In a letter written to an acquaintance nearly forty years later, Olga Schiemann commented on the level of survival skills Alice brought to her dunes life. "She had never learned to do anything for herself and when her mother died, she was completely helpless in the community. She had relatives that wanted to help her but she would have none of it. She simply got away from everyone."[44]

The idea that Alice "simply got away from everyone" could be in reference to her retreat to the dunes, but it might also explain why Alice accepted a job in Washington, D.C., and then spent several more years in Germany before returning to Chicago. Alice clearly wanted to prove she could take care of herself, eventually choosing to measure success by her own definition.

Writers and storytellers over time have proffered various theories to explain Alice's departure from Chicago. Although she said, "No love affair has caused me to live this lonesome life,"[45] it is a common theme; in fact, strong evidence exists that a complicated affair may indeed have been a reason she left.

The relationship was revealed in excerpts from Alice's diary, the pages of which she provided to the *Chicago Herald and Examiner* in 1918.[46] For a woman who valued her privacy so intensely, it seems curious that Alice would share publicly her thoughts about a man she called only "L," a writer for whom she had both intense and confounding feelings.

Others say, as did Alice, that she left Chicago because women were second-class citizens in the working world; she deeply resented being underpaid and undervalued. While speaking to a reporter, Alice insisted that "the life of a wage earner is a slavery."[47]

In a diary entry dated December 4, 1915, Alice wrote:

> *There was a letter for me from Dr. A., which, hastily read, spoiled my mood. Yet as I read it again there was no reason why it should. He assures me he has understood my case from the first—my abilities call for a better position. That statement revived the feeling which had made me almost loathe myself while I was doing the work: that I should be reduced, stooping to such means of earning money—what a prostitution of my powers!*[48]

Alice also expressed disillusionment with her work during an interview in 1916 with Honor Fanning, who claimed to be the first female reporter to "penetrate the sanctuary of this modern-world Diana." "I was working in Chicago, making little in the way of money, doing little of importance in

the world, it seemed. I had measured myself with the world—and the results were not encouraging. I came here to measure myself with nature."[49]

Another possible explanation for her exodus to the dunes derives from one of the first interviews Alice granted a Chicago reporter. "I must stay out here for a year....Friends told me last fall I could not live the life of a recluse two weeks without gaining a great deal of objectionable publicity....Thank goodness, though, I escaped until today."[50]

It seems feasible that Alice complained enough to her friends about her situation in Chicago that she was dared to set off on her own, leaving society behind as she attempted to commune with nature, like some Thoreauvian character. Perhaps she set her own timetable—one year—to prove her mettle among those who would doubt her success. It may not have seemed entirely risky, since her sister, Leonora, lived nearby in Michigan City, Indiana. (Family lore insists that while Alice lived in the dunes, she did visit her sister, although with what regularity is uncertain.)

The summer after her arrival, while speaking with a reporter about her search for solitude—by then, an utterly impossible dream for all the attention she had attracted—Alice grew hysterical. The interview occurred in the midst of her first long day of being besieged by newspapermen who were desperate enough to go thirteen miles south of Lake Michigan to Valparaiso, Indiana, in hopes of finding guides to her isolated shack.[51] Alice, the reporter wrote, "said sobbingly that she could 'readily understand why people were driven to suicide.'"[52]

On the surface, such a remark from Alice seems rooted in her frustration with the onslaught of questioning from various reporters. However, her diary hints that when she first came to the dunes, the notion of suicide was one with which she meant to reckon. Alice wrote of the day she left the city: "The day I arrived—the day that was crowded with thoughts of ending it all."[53]

Almost immediately, however, she was captivated by her new home. She admired nature's rich palette of colors, noted useful landmarks and pondered the vastness of her new environs:

> *Now, on this cloudy afternoon, as I sit and look over the milky green on the lake between the trees defined at the horizon with something darker than I should not know whether to call greenish or bluish or reddish. I feel sometimes as if I could faint with the rapture of it.*
>
> *Back of this hill there is a wonderful sweep of sand up to the heights—a great wash, really the great white way. From the top of that hill is a wide*

prospect—brown hills in the distance, over the tops of oak woods, and back to the lake between the dunes. The road I take to the farms and the railroads lies that way, sharp down into the oak forest in the valley. How exquisite the bare sand hills stand out coming back, especially in the subdued light at sunset.[54]

She gave thought to the question of "what I shall do when I get back?" in her diary entry of Sunday, December 5, 1915. By the following Wednesday, however, she determined that she would never return to Chicago. "And now a forever sadder and a wiser woman—let me forget that acridly chemical atmosphere—even corrosive atmosphere that I knew—now that I am living in the world that belongs to me and to which I belong."[55]

Whatever combination of reasons set Alice in motion toward the dunes, it is certain she had weathered a long winter, alone. From October of 1915 to midsummer of 1916, she busied herself with learning to survive in her new home.

Driftwood

The highest bravery in the world is loyalty to one's trust. It may be simply withholding the world, refusing to stoop to court, or to compromise, letting the world and its glory pass by without a regret or a thought, willing to be thought nothing, but in reality, in one's self possessing one's own desire.[56]
—*Alice Gray*

Finding shelter was an immediate concern for Alice, especially since she arrived in the dunes country just before winter. She told a reporter that she had moved into an abandoned fisherman's shack after four days spent sleeping outdoors. It was "ten feet square and without windows," as one news account described it; that same article provided its location, which had been discovered coincidentally by county surveyors working in the area. "The cabin is just behind the last bridge toward the hike…and only a narrow trail leads to it from this way after entering the dunes about half way between Baillytown and Dune Park."[57]

It was speculated that her shack at one time belonged to George "Sandhill" Blagge, a well-known dunes dweller who had died during the winter of 1914. Thought to be a Civil War veteran, Blagge was a gentle loner with whom neighbors gladly shared an occasional supper. That Alice took over his sandy turf was of no public concern—and fortunately, no one else laid claim to it.

As if to announce the transfer of property, she gave her sand-floored, crudely constructed shack a name: Driftwood. "Everything I have here, this chair, this cap I wear, these tins, are driftwood, drifted in from the lake—I, too, am driftwood."[58]

A photo of Alice's shack, which she named Driftwood. The photographer made a notation on the back that reads, in part: "I made the picture in the winter. She was inside." *Courtesy of the Westchester Township History Museum.*

But in that first winter, Alice made use of another encampment whenever she could. Known as Sassafras Lodge, it was a teepee, owned by naturalists Flora and William D. Richardson, located in a deep hollow of what is now the community of Dune Acres.[59]

In a memoir written by a friend of the Richardsons, Alice is mentioned—not in a kindly way—as a frequent visitor to their campsite. They discovered her much earlier than the newspaper reporters (although writing about her later, the author adopted the same colorful language of the press):

> *One day we discovered an unkempt, raggedly dressed, snarled hair subterfuge of a young woman had appropriated Sassafras Lodge as her permanent abode. Later a* Chicago Tribune *reporter publicized her in a series of articles as "Diana of the Dunes."…(We) permitted her to stay provided that on the days we were there she left it to us. This she usually did. We seldom saw her but saw signs of her but we could not understand the filth she left. It was a golden rule with us to always leave the Dunes as you found them.…We finally had to ask her to leave because the camp was so filthy and she herself so unkempt.*[60]

The True Story of Alice Gray

Naturalist William Richardson took many photographs during his visits from Chicago to the Indiana dunes. His property in Dune Acres is now known as the Richardson Wildlife Sanctuary. *Courtesy of the Westchester Township History Museum.*

A fall view of the teepee owned by naturalists Flora and William Richardson of Chicago. Early on, Alice often used the teepee when the Richardsons were away. *Courtesy of the Westchester Township History Museum.*

On the other hand, during the same general time period, Mathilda Burton, a fisherman's wife who claimed to be her nearest neighbor, noted that Alice kept her shack "scrupulously clean."[61]

Life in the dunes meant learning new approaches to ineffectual city ways: avoiding sunburn in constant exposure, staying warm during a winter storm, obtaining and storing food and supplies and finding stray materials to furnish a rough-hewn hut. Basic needs—including food and, for Alice, library books—forced her to walk into towns such as Chesterton, Miller, Porter, Baillytown, Furnessville and Michigan City.

In her diary, Alice described some of the immediate challenges she faced in her new life. Because she feared strangers would steal her meager belongings, she kept close watch on them. She collected pine boughs and added them to her oil cloth and blanket bedding to help block the cold from her mattress of sand, and she knocked on farmhouse doors hoping to buy bread, milk and eggs from homeowners. One evening, she was reminded of a fundamental lesson regarding her most plentiful resource, sand:

> *I remembered that it had rained a little the night before, and my blankets were a little damp. So I built a fire in the iron box I had found ready at hand, which makes cooking so unexpectedly convenient, and spread out my possessions on the ground around it....Feeling very happy and domestic and much pleased with myself and the world, my world, large and small—when, the fire dying down, and my towels being not quite dry, I moved the iron firebox with the idea that the sand under it would be the best means of finishing the drying, and deliberately put my hand—my right hand—caressingly on the sand to see if it was warm enough to do the towel much good, I suppose. My God—how it hurt! The shame of having done such a fool thing was hardly second to the pain of the burn.*[62]

The next day, she inventoried her "pre-breakfast" food supply. "My stores are now reduced to three eggs, half a slice of bread, a little oatmeal, coffee and salt, a bacon rind and some grease, a cabbage and a very few apples and radishes."[63]

A 1916 newspaper article asserts that Alice, in pursuit of food, became quite a huntress, based on the number of trophies hung on a line outside her cabin. The reporter described her deft marksmanship: "During all the bright nights the wild ducks remain out on Lake Michigan. At dawn they come flying in to seek the little marshes as their feeding ground. Miss Gray is ready at the last ridge and as the birds come over she pops them right and left."[64]

The True Story of Alice Gray

However, in a letter written in 1954 by Olga Schiemann,[65] it was noted that the "revolver" Alice brought with her to the dunes "rusted immediately and was never shot off." In a second letter, Schiemann refers to the same worthless weapon as a "shot gun."

Schiemann befriended Alice after stumbling upon her shanty in the dunes. Her family often fed Alice during those first few years of dunes living. "It happened she chose a spot very close to where we were staying and we adopted her when we were there over the weekends."[66]

The Schiemanns weren't the only family to share food and conversation with Alice. The late Margaret Larson, lifetime resident of the area, wrote about Alice in her memoirs:

> *One day when I returned home from school my mother happily said, "I had company today! You know people have been talking about a woman who seems to be in the dunes just like George Blagg." Well, this woman came to the door and had been told that mother had known all about the Bailly family. She introduced herself as "Alice Mabel Gray" of Chicago but was living in the dunes. My mother invited her to come in, although she said she was perturbed since her visitor was dressed in men's clothing and had a "deep voice." As it turned out they visited several hours and when Alice got ready to leave mother loaned her our copy of Frances Howe's* French Homestead in the Old Northwest. *Alice noticed the rows of books in the bookcase and said, "I'll be back, please."*[67]

Larson recalled that Alice visited "many" families in Baillytown—on Saturdays to pick up someone's molasses cookies, once to get help from another neighbor in laying a pattern on material for a skirt or occasionally to visit with Agnes Larson, Margaret's mother, for coffee or a taste of Swedish rye bread.[68]

Hazel Blythe, another longtime resident, said her family lore relates that Alice bought baked goods from her grandmother, Anna Larson. Her aunt, Ethel Larson, a librarian in nearby Miller, used to say that Alice "was a very intelligent lady, read a lot, and checked out large armloads of books." Blythe noted that her family consensus was simply this: "A lot of things written about 'Diana' were not true."

Accounts of Alice's personal appearance also vary, mostly relative to the seasons. In her first years in the dunes, it can be gleaned from newspaper accounts and from those who met her that she typically wore simple skirts with middy tops or rumpled dresses; it was reported that she favored wearing black, but likely it was one black outfit that she wore time and again.

DIANA OF THE DUNES

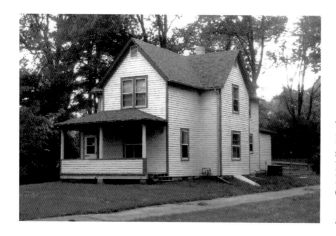

The home of Margaret Larson, which now serves as the Indiana Dunes National Lakeshore Learning Center. *Courtesy of the Westchester Township History Museum.*

By all accounts, Alice wore her dark hair short, or "bobbed," a style consistent throughout her dunes years. During her interview with the reporter, Burton, the fisherman's wife, said that Alice cut her own hair, judging its desirable length and shape by the shadow she saw of herself in the sand.[69]

Although possessing a mirror might have seemed an extravagance to Alice, or at least difficult to come by, without one she was unaware of how she appeared to others. She apparently offended the Richardson camping group with her looks, but they weren't the only ones—and sometimes, she even frightened herself:

> *I wonder if this life is really as good for me as I thought. I stopped in cheerily on my way back to see Mrs. B. Combing her hair, she referred to her looks, and that reminded me to look in the glass. What a sight! I looked like a delirious Indian. Nose red from a little cold and much wiping—eyes pale and staring in the general smoky red, teeth pearly by contrast, and, oh, what a forlorn, unwashed, gaunt face!*
>
> *This morning I washed in hot water and plenty of soap—I had only a rub off before since the day by the fire in the wigwam—and looked civilized except—as the glass revealed—for a grimy underchin and neck.*[70]

In a second diary entry, she wrote:

> *Friday I walked to Oak Hill and while waiting for Mrs. Larson to come home with my groceries I had the first good look I have had of myself in some time. To tell the truth, I was rather shocked. My eyes seemed to have a rather*

The True Story of Alice Gray

wild, strained look as if the life I was leading were very wearing on me. I said to myself that I would be afraid if I met myself alone at the crossroad in the moonlight. However, I was not so bad with my hat and coat on.[71]

The idea of Alice walking great distances is a popular one. She was reported to have walked for miles at a time—among the dunes, from the dunes into one town or another and all along the beach, including from Driftwood to her sister's home in Michigan City, Indiana. Marion LaRocco, Alice's great-niece, said her family was often amazed by how far Alice traversed on foot—she sometimes journeyed from the University of Chicago campus to the home of a niece who lived on the north side of the city. LaRocco heard such stories about Alice from her mother, Dorothy Dunn Noble, and her aunt, Marion Dunn, twin daughters of Alice's sister, Leonora. They were in high school during the time Alice lived in the dunes region.

When Alice walked to Michigan City, LaRocco said, she was not just out for the exercise: "My mother said Alice once in a while appeared without warning late in the morning. She would have the worst attire on—men's trousers and a gunny sack for a shirt." Knowing that Marion and Dorothy came home from school for lunch, Alice arrived early so she could be sure to talk with them. "She wanted to go to school with them, too. But the girls would slide out the back door and get back to school without her," LaRocco said. They loved their Aunt Alice—the entire family thought she was "brilliant" and interesting—but the twins were simply too embarrassed by her clothing.

The *Gary Evening Post*[72] reported that Alice never wore shoes or stockings in the summer but wore big boots in the winter. In warmer weather, she wore a light dress with a "ragged waist" over it and, in winter, the same ragged waist

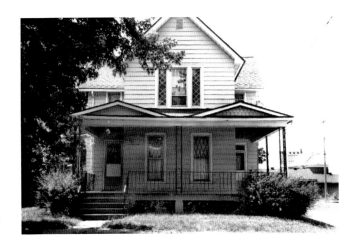

The home of Alice Gray's sister, Leonora (Gray) Dunn, in Michigan City, Indiana, as it appears in modern times. *Courtesy of the author.*

A deep winter snow blankets the teepee, known as Sassafras Lodge, owned by Flora and William Richardson. Alice was known to use the teepee when the Richardsons were not visiting the dunes. *Courtesy of the Westchester Township History Museum.*

over a short, coarse skirt and a "little cap"—probably the same cap Alice mentioned as part of her "driftwood" possessions.

Burton described Alice's winter attire as "heavy mackinaw socks, such as lumberjacks wear," a man's cap, a gray wool skirt and a knee-length coat.

Her appearance, notable due to its plainness, was generally tolerated in deference to her way of life.

Those who knew Alice found her not only sane and friendly but also fascinating because of the wide range of topics she could discuss. Perhaps, too, her voice—which had some remarkable quality—added an element of wonder to conversations. Although Larson's mother described it as deep, it has also been called pleasant[73] and lilting.[74] LaRocco said that Alice loved to listen to her niece, Dorothy, play the piano. "Alice didn't seem to be musical herself, except for her voice. My mother used to say her speaking voice was beautiful."

Schiemann described Alice in a letter written to an acquaintance in 1952:

> *Several years of sun and wind on her hair and skin didn't make it look any better. She had no iron to iron the clothes which the sun soon bleached out, so she didn't look like the ordinary person, but I grew very fond of her and*

The True Story of Alice Gray

we often spent long hours together around the fire after the others had gone to bed while she told me about the stars in the heavens, etc. She was a freak or eccentric to most people then and yet, but I stood up in a couple of meetings of Duneland [Historical Society] defending her as best I could.[75]

During an oral history project, two longtime residents of Chesterton, whose families knew Alice, spoke of their early experiences.[76] Margaret Larson was one of them, along with Evelyn Shrock, now deceased.

For many years, the city of Chesterton, Indiana, held a Diana of the Dunes festival. The Duneland Chamber of Commerce ended the tradition in 1999 because of dwindling attendance, but not before many annual contests for young women had proclaimed the winner as Diana of the Dunes. Larson found a touch of irony in this: "People couldn't figure (Alice Gray) out, you know. To the people who do the pageant now, she is just an imaginary thing. These girls who are so anxious to be named 'Diana of the Dunes' don't know what they're doing, because she was not very glamorous."

Evelyn Shrock remembered her mother enjoying Alice's company. "She used to come to our house and my mother would fix her a cup of coffee and a slice of homemade bread, maybe made into a sandwich. She would sit and talk to her. She was as interesting as she could be."

The late Myrtle Isbey, who was a longtime Porter resident and part of the same oral history project, recalled Alice's unusual appearance: "I remember when she roamed the beach, dressed in a gunny sack with that little bitty hat. That was in 1915. I knew her. She was a very smart woman, but boy she was quaint."

Dorothy Johnson Higgins, deceased, used to speak of her younger half sister, Helen Mentzer, swimming as a child with Alice in Lake Michigan.

Dr. Richard Whitney, now a resident of California, spent many summers of his childhood roaming the sand hills of Indiana and the beach along Lake Michigan. Landmarks and roads were few back then, but he believes his family's cottage was somewhere between what is now Dune Acres and Miller Beach. In a 2005 interview, he recalled playing hide-and-seek with other children in the woods. "Never a day went by that Diana of the Dunes was not part of our pretend games," he said, noting that one of the boys would inevitably ask, "What if we run into *her*?" Although they did not regard Alice as a fearful creature, the thought of her did conjure up a witch-like character—"but a good witch," Whitney remembered. To their extreme disappointment, the encounter never happened.

But they did see her elsewhere. As children, Whitney and his pals walked barefoot to a general store with pennies in their pockets to buy a Mary

DIANA OF THE DUNES

In this photo, the woman seated to the far right of the picnic-goers is assumed to be Alice Gray. The photo, published in the *Gary Post-Tribune* on December 29, 1963, was discovered by the late Arthur Johnson of Porter, Indiana, among his family albums.

Jane or a Tootsie Roll. Occasionally, Alice would be in the store and there would be some commotion about her. He also recalled that every so often his neighbors would spread the word that Alice was out in public buying supplies. Some then dashed into town, hoping to catch a glimpse of her.

Such vivid oral histories about Alice are valuable and few. In Alice's case, the primary sources used to develop her story are newspaper articles, a good many of which featured bad reporting and the sometimes tall tales of local townspeople. These are mingled with truer stories told by those who met her or whose families pass their original Diana stories to the next generation. Often, it is difficult to sift fact from fiction. In reading over the body of news stories from the time, however, certain consistencies rise to the top, while obvious distortions sink from the added weight of their falseness.

Reading those many articles in context with other sources—such as the oral histories from people who knew Alice or whose families had knowledge of Alice, personal letters or comments written by her contemporaries and published excerpts from Alice's diary—some underlying assumptions become more certain.

In those early years, she did not live the life of a hermit, but neither did she seek attention. Her actions seemed to be guided by the necessities of survival; her quietude was devoted to discovering herself, as well as her environs:

The True Story of Alice Gray

I have been—for me—just a little depressed the last few days—ever since I came up here, perhaps; but think it has been due entirely to physical causes—food and thin clothing. How glorious this outdoor life is—how good life feels and tastes and smells down close to the great elemental things; this blazing fire, with the white brilliance in the west, just one star (Venus or Jupiter?) high up in the southeast, the dull white snow patches in the hollow and on the southern slopes, and the snow-flecks brown of the western slope, and the light gone for writing and the time come for supper.[77]

It does not seem far-fetched that as one of those necessary activities, Alice swam naked in Lake Michigan. Although legend has it that she did so at the first sign of ice melting on the lake and continued to do so until ice returned the following season, she discounted reports of brave winter plunges. "Just don't imagine that I spend my days and nights up here going in bathing (I did go in yesterday, but I'd like to see myself going in just now with the frost still in the air), climbing hills to gaze at views and wiggling my toes before the fire. Far from it."[78]

It's a matter of practicality that Alice bathed in the lake (twice daily, morning and early evening, so the rumor went) when temperatures allowed for it. (To some, it would be a wonder if she didn't swim five times a day during the blazing heat of an Indiana summer.) And if she did so without clothing, as fishermen claimed, she was keeping clean and dry what few clothes she owned. Bearing in mind that Alice lived in an area that was generally uninhabited and not commonly visited by townspeople or vacationers, her behavior does not seem so suspect. Only after Alice was discovered did fishermen put her on their regular route, and even then it was often with sightseers aboard who were hoping to see the "mermaid." Later accounts assert that she did don a bathing suit, no doubt because the encroachment of civilization spoiled the notion that her location could be considered remote.

Once she arrived in the dunes, it did not take Alice long to begin contemplating her new life. While she was satisfied, she was not immediately comfortable with her solitary existence. She had been away from Chicago less than a month when she wrote the following:

Generally, especially when I write, or walk, or sing, or read, or recite my favorite poems—I am very, very happy and contented with my lot and my course. Then once in a while I wonder if I am childish, futile, foolish, a "skulker" as some one called Thoreau—a nonentity, a shirker and deserter and coward and egoist. Yesterday was one of the days of such doubt of myself.[79]

A Message from the Sea, etching by Earl H. Reed and published in his book, *Voices of the Dunes*. Courtesy of the Westchester Township History Museum.

While she fought off self-doubt, she also wrestled with the rhythm of solitude and the inevitable rising of imponderables: "Yesterday I longed for society—the companionship of some big, clear-eyed, single-hearted, frank soul, who would talk to me…about life and love, about God, freedom, immortality."[80]

It would be several years before Alice found a constant companion with whom to share her dunes life.

Surfacing in the Dunes

It is a country for the dreamer and the poet, who would cherish its secrets, open enchanted locks, and explore hidden vistas, which the Spirit of the Dunes has kept for those who understand.[81]
—Earl H. Reed

July today emulated the drive of allies and swept the city with liquid fire.[82]
—*the* Gary Tribune, *1916*

Mysterious, gravitational swings in behaviors and temperaments swept through the Indiana summer of 1916. Odd things were happening; some explainable, others strange enough to put folks on edge. Local newspaper stories, published just during the weeks of July, show just how crazy the world had gone.

Perhaps the mystique of the spectacular solar eclipse that month inspired some cosmic sense of change and rebellion.[83]

Or maybe it was fueled by grief. James Whitcomb Riley, the state's beloved poet, "the children's friend," died that July. As his body lay in state, thousands lined the streets around the Indianapolis State House, waiting to pay their last respects. There was talk of naming a proposed national park in the Indiana dunes region in honor of the bard.

Political battles brewed, too. The cry for a Sand Dunes National Park stirred individuals, groups and cities all along the southern edge of Lake Michigan. Editors splashed headlines across the pages of their local newspapers touting

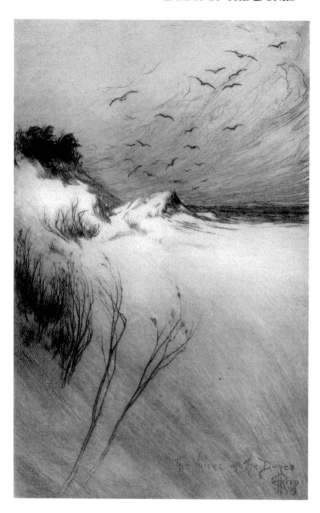

Voices of the Dunes, etching made by Earl H. Reed, author of the book by the same name. *Courtesy of the Westchester Township History Museum.*

articles and editorials that left little doubt where their allegiances lay. A rally designed to raise awareness and stir the souls of supporters was staged at the foot of Mount Tom, the region's tallest dune. The event received plenty of coverage, much of it echoing the same sentiment: preserve the exquisite beauty and rare ecological wonders of the dunes for the sake of posterity.[84] Besides, organizers argued, the Midwest was sorely in need of a convenient vacation destination.

Some estimates placed the number of people attending the rally at several thousand; however, most participants opted to cool off in the lake rather than listen to speeches given in a blowout of the dunes. It was a hot day after all, and many had traveled some distance by car or train to attend. Why not enjoy the surroundings they had gathered to protect?

The True Story of Alice Gray

Front pages also captivated the public with some less important, but otherwise adventurous, stories featuring odd twists. Two articles about "woodswomen" were still fresh in their minds when readers first discovered Alice in news pages the following week.

One local paper reported that seven women planned to live for a month as "modern Eves" in the Adirondacks, under the watchful eye of a male naturalist, to prove that "women as well as men can live in the woods by their own devices and with what nature offers."[85] John Knowles planned to find his entourage a camp, leave them for a month to enjoy his own solace and return to fetch the women on his way back to civilization.

The same week, the *Porter County Vidette* reported that five women hailing from nearby Illinois towns were intent on hiking twenty miles a day through Indiana. Their final destination was a summer camp in Niles, Michigan. Attired in "appropriate costume," the women wore "short skirts of durable canvas, stockings that look like socks, heavy boots, military capes and broad hats."[86] According to the article, they were all looking forward to the exercise.

While voting rights and the opportunity to hold representative seats in Congress were high on the list of priorities for female activists at the time, women across the country were stretching in other political ways as well. Under the headline "What Will These Women Try Next? They Want a Birth Control Exhibit at Duluth Lecture," readers learned of the radical birth-control philosophies espoused by Mrs. Robert Liggett of Duluth, Minnesota, and the questionable mass mailing tactics of Margaret Sanger of New York, a prominent birth-control advocate and women's rights activist.[87]

Closer to home, a fluke incident required the emergency aid of Gary Boy Scouts. They answered the call to hunt with harpoons for a baby shark that escaped from a college professor's care into Lake Michigan.[88] The professor had intended to present the shark as a gift to a local school. The shark, meantime, had already attacked a twelve-year-old boy, mauling his feet. Residents feared worse if the shark adapted to its new freshwater home and grew.[89]

The month-long blistering heat that nearly broke the back of the Midwest was by far the biggest story. The torrent of hot weather did not spare the Greater Gary region. Records were set for both high temperatures and death rates, while serious ice shortages caused problems, especially for hospitals. The sweltering days created havoc and spawned riots along the beaches of Lake Michigan. In Hammond, Indiana, officials installed a large clock near the beach to encourage bathers to be mindful of each other and voluntarily limit their time in the lake to two hours. Swimming overtime was an issue that went beyond overcrowded conditions, however; in those days, most bathers rented their swimsuits:

"By remaining in the water three or four or five hours bathers renting suits monopolized them while a long line waited outside the turnstile last Sunday."[90]

Laundering swimsuits in between uses was a general practice. In the oppressive heat, the usual standards fell a few notches: "So great was the demand for bathing suits that they were used again without drying, eager ones getting into 'em wet."[91]

Throughout the month, beaches—and the roads used to reach them— were jammed.

> *With the temperature at the highest point ever reached since Gary started, the shore of Lake Michigan from Pine east to Tremont, 17 miles away, was alive with human beings seeking the relief to be gained from the cooling waters.*
>
> *On the beach, thousands of people were splashing in the water at one time. The Carr bath house early in the day hung out the sign that all bathing suits were rented.*[92]

Following are dire headlines in a Chicago newspaper, all published on the same day, July 30, 1916:[93]

> *Dwellers in Ghetto Walk All Night to Escape Heat—Firemen Turn Rain Clouds; Cool Streets with Hose—Let Men Remove Coates in Cafés, Says Coroner—Protests Against Hot Uniforms of Policemen—Mercury at 109 in Gary—County Hospital Centers Efforts on Heat Victims—Thousands Beg Chance to Sleep on Municipal Pier.*

The waves of suffocating summer heat rolling through Indiana crashed into the roiling political waves of World War I. Published reports from Europe were long and frequent in local newspapers.

Timing, they say, is everything.

In the midst of this national and international contentiousness, public anxiety over strange phenomena and the intense heat that marked both days and nights, the newspapers hoisted Alice Gray from beneath the swell like a trophy fish caught on the final run—unsuspecting, unwilling and greatly exaggerated. Immediately, she found herself cast as the diversion in a nervous, heat-stricken community, a giddy overture to the more serious business of politics and a vulnerable target for lack of fortified defenses. Alice could not have anticipated the tremendous attention she would attract or the awkward, insensitive rush of celebrity that quickly followed. Her second thoughts about staying in the dunes—and she did have them—must have come fast and furious.

Diana of the Dunes

Cleaving the water like a milk white dolphin came a mermaid. She made the shallows, rose up out of the water, then like a fabled nymph, flitted off into the shadows.[94]
—*the* Lake County Times, *1916*

For four years Diana of the Dunes has been the most interesting character in all northern Indiana. As a student she was very bright, a skillful typist, and fitted to make a good living if she had chosen the ordinary way.[95]
—*the* Lake County Times, *1918*

A flurry of newspaper stories first announced the presence of Alice Gray during the summer of 1916, nine months after she settled in the dunes. Although spare in background detail, these fledgling glimpses of Alice hit the newspapers with all the sensationalism reporters could muster. Accounts of a lonely nymph living in the wild sand hills thrilled readers in Chicago, throughout Indiana and northward into Michigan; even today, strong vestiges of these early, romantic portrayals remain in legendary stories of Alice.

Initially, her identity was a mystery. Newspapers printed their own guesses. They speculated on whether Alice was Miss Elizabeth Wilkins, a former University of Chicago instructor, or Miss Wilhelmina Wilkins (apparently unrelated), an heiress of Walla Walla, Washington, who had disappeared two years before.[96] These women, and perhaps others who had gone missing from polite society, gained renewed attention in Alice's story.

Diana of the Dunes

While a number of "hermits" had settled in the region over the years, Alice likely attracted such unprecedented attention because she was younger and female, an unconventional candidate for such a difficult existence. The others who came before her were whiskered old men with colorful stories, mostly loners who kept to themselves. Author and artist Earl H. Reed, a Chicagoan, often visited the dunes region, sketching and writing about such local inhabitants as Old Sipes, Happy Cal, Catfish John and Doc Looney. They, too, had given up on society for one reason or another. They were crusty, though, eking out a meager existence as if it were second nature. Alice, on the other hand, seemed refined, educated and a bit too spoiled to make a serious attempt at living in the dunes. Her brashness captured the spirit of the dunes, however, and apparently folks wanted to know how was she doing; was she going to make it? Reporters kept close tabs on her—at least in the beginning, then intermittently. That is, until an incident in the summer of 1922; one that would dramatically change the dynamic between Alice and the press.

The first reporters, the ones who announced Alice to the region in 1916, focused more on selling newspapers than recording the truth, so words like "recluse," "nymph" and "mermaid" populated their writings. A short time later, thanks to the creative impulse of an unknown editor, Alice became Diana of the Dunes.

Dunes dweller George Blagge died in 1914. It is speculated that Alice Gray moved into his abandoned shack in 1915. This photo was reprinted in Margaret A. Larson's *Memoirs of Old Baileytown 'Plus.'*

The True Story of Alice Gray

Early on, however, newspapers also labeled Alice as the Mysterious Nymph of the Sand Dunes.[97] The reference to "nymph" derived, at least in part, from her reported penchant for bathing naked in the lake. Her habit was discovered by fishermen who were content to keep their distance but who apparently relished spreading the word. Newspapers were tipped off to the story by a fisherman's wife. On July 21, 1916, several rival reporters visited Alice, their accounts appearing in print the next day.

The *Lake County Times*, an Indiana newspaper, spiced up the story this way: "Twice daily, according to fishermen, the nymph of the dunes, whose name is not known, takes her plunge like a goddess of the wave."[98]

Two days later, the same newspaper changed its tone: "Of course it's all right to call her a beautiful nymph and tell of the gleam of her white glistening skin as she bathes like Venus in the waters and all that, but the fact remains that she's 40 and brown as a berry and tolerably husky."[99]

Alice was neither beautiful nor yet age forty. She was thirty-five, unconcerned with presenting a stylish appearance and adamantly independent.

Adding to her mystique, Alice confounded people by speaking intelligently and—especially with reporters—emotionally. While staunchly guarding her privacy on her own sandy ridge, Alice felt comfortable talking with

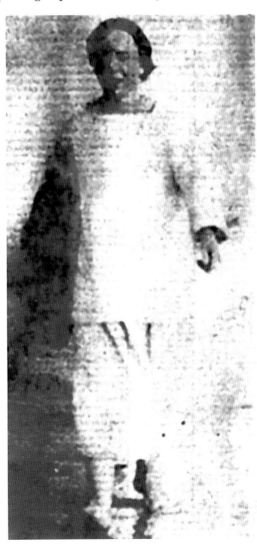

A photograph of Alice Gray published in the *Chicago Sunday Herald* on July 23, 1916, just after fishermen discovered her in the dunes.

folks when she walked into town, most of whom posed no threat to her. If anything, she was a curiosity. Both children and adults followed her into a local store or the library, just to catch a glimpse of the strange woman they had heard about from neighbors and newspapers.

Ironically, a Chicago reporter, one of the first to interview her, seemed cautious of the information Alice shared, and with good reason. She falsified her history—for the first time but certainly not the last. During the interview, Alice said she moved to the dunes because a specialist "blundered" in treating her eyes; she had no choice but to give up working. There is no evidence that she had problems with her vision. She also informed her interviewer that although her mail arrived addressed to "A.M. Gray," the name was assuredly fictitious.

Underlying the reporter's words is an observance that his subject's temperament seemed shaky at best. The article described Alice alternately as a "nymph," "recluse," "young woman" and a "girl," who was both "hostile" and "hysterical," pacing back and forth on the beach as they talked. At the same time, Alice's intelligence came through, despite any frenzied antics on her part. The reporter took some liberty in describing her background, using her supposed pseudonym cautiously by placing it in quotations:

> *"Miss Gray" is a young woman apparently of English descent. Judging from her conversation, she has a broad classical and general education. Her skin is brown and despite her assertions that she is living in the wild because of ill health, she has the appearance of one who never has been ill in her life....She is intensely temperamental. Angry moments were followed by laughter.*[100]

The reporter concluded, as many others have since: "Altogether, the 'nymph of the dunes' is a mysterious person."

The *Lake County Times* news story, running under the headline "Nymph Is Plump and Forty," took a more pronounced slant regarding her mental capacity:

> *From a distance they saw the lonely inhabitant. Her black hair was bobbed and she wore a black dress....She can converse fluently on any subject and her speech indicates past refinement and culture until an unsteady brain led her into her odd illusions. She is the queen of the hills, she claims. Her name she has never mentioned. She takes her daily dips in the lake and appears happy. Occasionally she walks to Porter and buys supplies, and her money seems to be plentiful.*[101]

The True Story of Alice Gray

Alice's story became well known so quickly that even in passing reference she became noteworthy in Chicago:

> *The "Nymph of the Dunes" was outnymphed yesterday. Three small boys created a stir on the University of Chicago campus when, clad in the scantiest of garments, they plunged into the Hull court fountain in full view of an admiring throng.*[102]

At the same time Alice's existence was announced, newspapers were busy covering the push by Chicago naturalists to preserve the dunes region. A Gary, Indiana headline voiced suspicion about the timing of her discovery: "Is This a Scheme to Attract People to Dune Region?"[103]

And then there was a letter-to-the-editor writer who suggested that Alice be put in charge of the proposed national park. "I haven't the slightest idea who she is, but I feel she would make good," he wrote.[104]

A newspaper writer responded:

> *Even though Mr. Damon hasn't "any idea who she is," the rest of the world knows by this time that Diana of the Dunes is Miss Alice Gray, who lives in her hut by the lake and takes her morning plunge without reference to beach rules in the matter of clothing. And if the dunes are to become a national park, she is already in charge—with an automatic gun to back her authority.*[105]

Alice hid for a while in the sand hills the first day reporters arrived. Realizing they did not intend to give up, however, she appeared before them, one by one. They heaved thick questions, like wet sand clots, aimed directly at her sensibilities, sending Alice into another whirlwind of doubts about how she was leading her life. Several articles, all of them printed July 26, 1916, suggest that after notoriety arrived, she faltered, reconsidering her decision to stay in the dunes.

Under the headline "Nymph O' Dunes Visits Chicago," published in the *Lake County Times*, the writer trumpets his discovery of her in the big city, dining in the College Inn, a trendy restaurant and up-and-coming jazz venue located in the celebrated Hotel Sherman at West Randolph and North Clark Streets.

With the public revelation about Alice's castaway life only four days old, already reporters recognized her outside the realm of her remote sand hills, or so the article maintained.

> *After sight-seeing Miss Gray dined in the College Inn, and then watched the dancers whirling about, her eyes bright with interest and her lips half-parted in amazement and amusement.*
>
> *She soon was recognized and chatted freely with newspaper reporters, who were well-represented....*
>
> *"Really, I should love to dance, but I don't know how," she said in response to an invitation. "I just want to watch the others. Am I going back to live on the dunes? Really, I don't know. Oh, Solitude—"*[106]

One newspaper invited Alice to write her own account of her visit back to Chicago. She visited downtown Chicago, taking in her first motion picture and wandering along the city's newest attraction, Municipal Pier (known since 1927 as Navy Pier). Of the pier, she wrote: "It takes perhaps an hour in the street car for the average Chicagoan to get there. But your millions for this, and not a quarter of a million to save the dunes from being Garyized, with the dunes now only an hour away by train. Is this forward-thinking, Chicago?"[107]

In response to the question of whether she would leave the dunes and move back to the city, Alice wrote, "I love the great silent darkness up there; the silence that lives in the noise of winds and water, the darkness that finds itself in the fleeting, eternal waves of those reaches of waste sand; the only reality of life for me is there."[108]

A second story, borrowed from the *Michigan City Dispatch* and reprinted by the *Gary Evening Post*, originates from the dunes, although whether Alice spoke directly to reporters is unclear. The headline summed up, rather matter-of-factly, public sentiment regarding her departure from Chicago and the gravity of her presence in the dunes: "Diana of the Dunes May Go Back to Life."

> *The sand dunes...are to lose the young woman hermit who was discovered Friday living the simple life in a hut near the shore of Lake Michigan. The newspaper publicity has resulted in daily pilgrimages being made to her home, to her great annoyance, and she now threatens to migrate to some other out of the way place, where she can be alone.*[109]

A third headline, "'Diana of the Dunes' Flees Her Habitation," ran above a brief paragraph on page one in the *Porter County Vidette*. Someone spotted Alice at the train station, on her way out of the dunes. "'Diana of the Dunes' left her habitation yesterday and today is very likely back in the

The True Story of Alice Gray

rush of Chicago. The woman took a South Shore car at Oak Hill yesterday morning and seemed very busy on a manuscript."[110]

(Regarding Alice's penchant for working on manuscripts, this tantalizing image pops up throughout her story, but none of the manuscripts has been found.)

From the reporting, it seems that Alice explored two options: retreat to Chicago, with all the workday frustrations of city living she had left behind, or move to another isolated location along Lake Michigan.

However conflicted, Alice did neither, exercising instead a third option: she asserted her right to remain in the dunes and occupy the same shack, swim along the same shoreline and follow the same paths into town. Certainly, she had a clue that the ensuing publicity would be relentless, although she must have hoped, even assumed, that it would die down after a while. Why else would she stay?

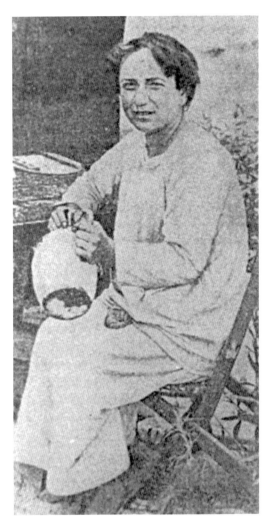

A photograph of Alice Gray published in the *Indianapolis Star* on February 12, 1925.

It is possible that Alice stayed in the dunes region where she first settled because she had made some friends there, folks she relied on—for blueberries (which she hated to pick herself), for bread and salt, for brief moments over coffee in a warm kitchen, for books and for sturdier shelter when temperatures became unbearable. This small circle of acquaintances helped her endure a winter largely under her own care; they were an

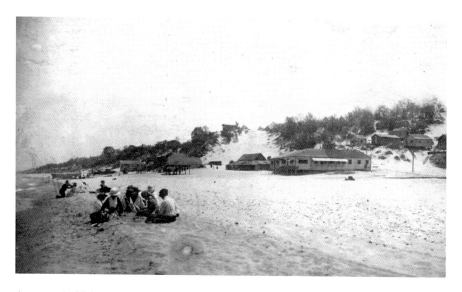

A postcard of Waverly Beach in Chesterton, Indiana, in the early 1900s. The area is now known as Indiana Dunes State Park. *Courtesy of the author.*

important group, and her survival was a difficult feat. It might have been too outrageous a thought to simply walk away from such important connections—such gifts.

But her love for the dunes and the freedom the region provided for Alice were powerful influences, too. On December 8, 1915, she wrote, "If I had not been desperate I should not have thought of coming up here; and how wonderful, how unspeakably healing and sanctifying it has been living in all this beauty and this keenly vital air and in the blessed solitude."[111]

Besides, by the time the gossip chain and newspaper operations snagged Alice's story, it was summertime. The stoic, glistening sand hills, the deep and ever-changing hues and moods of Lake Michigan, the lush woods—all are beautiful in mid-July. Who would trade such a vista, such a glorious horizon—one made more stunning with each new day of mesmerizing clouds, broad sunsets or fast-moving storm fronts—for crowded streets and the politics of a working life in the city, especially if she had a choice to remain? Alice had beaten back winter; it was time to welcome the warmer days ahead and claim those, too.

Fullerton Hall

> *Besides its nearness to Chicago and its beauty, its spiritual power, there is between the Dune Country and the city a more than sentimental bond—a family tie. To see the Dunes destroyed would be for Chicago the sacrilegious sin which is not forgiven.*[112]
> *—Alice Gray*

Two photographs of Alice were taken by the *Chicago Daily News* in 1917.[113] One portrait shows her formally posed, seated sideways in a bentwood chair and wearing a loose, dark dress, floor length, with no collar. In the other image, some embroidery and cutwork embellishing the long sleeves and vest-like bodice is evident. Alice wore thick shoes. Her hair was short, trimmed just above her ears from a high forehead, and it was straight, with no bangs, curls or other special attentions. Alice was not smiling; rather, she gazed soberly to the side and behind the camera.

In all likelihood, the photographs were meant to illustrate an upcoming story about an assembly to garner attention for preservation of the dunes. Along with Lorado Taft, renowned architect and sculptor, and others, Alice was a featured speaker during the town hall meeting, held at Fullerton Hall in the Art Institute of Chicago on April 6, 1917.[114]

If the locals were still questioning the neighborly role of Alice, the Prairie Club provided an answer. An association of outdoor enthusiasts hailing mostly from Chicago, the group built a retreat house in 1913 at Tremont, a popular area of sand hills encompassing Waverly Beach (now known as

One of two photos taken of Alice Gray by the *Chicago Daily News* in 1917. *Courtesy of the Chicago History Museum.*

Indiana Dunes State Park). Prairie Club visitors frequently hiked throughout the woods and bald dunes and enjoyed the beach areas; they became intent on protecting the region against further industrialization. Members called the Chicago meeting in an effort to muster support for their proposal to create a national park along Lake Michigan in Indiana and to outline a historical pageant intended to honor the region's history:

> *In no better way could the value and beauty of the Dunes be shown the residents of Indiana and Illinois than by an historical pageant which would in the first part accent the remarkable connection of the Dune country with American history, and in the second part project the wonder and beauty of the Dunes, through poetry, music and dancing.*[115]

Alice was invited to speak at the Chicago meeting about her experiences living in the dunes and to expound on the environmental wonders she

had encountered. After all, she had managed to survive in the wilderness, alone, for eighteen months, a testament to the healing, protective powers of living among nature. As far as the Prairie Club was concerned, Alice was a conservation sensation; with a bit of exaggeration regarding her age (which was thirty-five at the time), newspapers indulged the idea:

> *The girl, who is in her early twenties, shows in her face of beaming good health and happiness the reasons why she loves the dunes and will do anything to save them. She has a voice like a bird for its lilting quality, and walks with the spring of a native woodsman. Side by side in her cabin are the roughest implements for life in the open, and volumes that indicate her taste for abstruse reading and study.*[116]

It's possible that some Prairie Club hikers knew Alice during her days at the University of Chicago. Professors who were members—especially Henry Chandler Cowles, renowned for his dunes ecology studies—often brought students into the sand hills for exploration and lessons in botany. It would not be a stretch to imagine her brushing up against these academic groups during their visits. There is no mention, however, of Alice having explored the dunes area during her own college years or, for that matter, as a child. However, it seems likely that Alice had at least visited the beach in Michigan City; her sister, Leonora, had lived in that city for nearly two decades by then.

For her speech, Alice read an essay she wrote that urged Chicagoans to lead the fight against further industrial development of the dunes. In doing so, she gave a lyrical history of its glacial era:

> *So the glacier which came down from the north to give Illinois its chief treasure—its deep, rich soil—tarried at Chicago on the way back to give birth to the lake.... To the east, in Indiana, it left a somewhat narrower strip of fine level sand. In this the northwest wind, having shared with Chicago its vigor and joy and renewed its delight as it passed over the lake, has moulded the dunes.*

Titled "Chicago's Kinland," Alice's essay was later printed in a bulletin published by the Prairie Club.[117] The pageant discussed during the meeting, "The Dunes Under Four Flags," was held May 30 and June 3, 1917, attracting forty thousand or more people by most accounts. Alice Gray's name is not listed among the many volunteers or performers in the event program, nor is there any newspaper mention of her attendance.

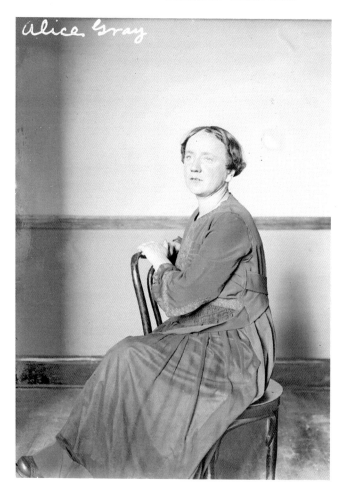

One of two photos taken of Alice Gray by the *Chicago Daily News* in 1917. *Courtesy of the Chicago History Museum.*

The same day the Fullerton Hall meeting was announced, the United States announced its intention to enter World War I. Overshadowed by this extraordinary national declaration, the photographs of Alice were never published by the *Chicago Daily News*; the announcement received only a small, one-paragraph mention, although it did run in the lower, right-hand corner of the newspaper's front page, buried alongside the full text of President Woodrow Wilson's war message and far below the thick banner headline that read: "War Declared."

Paul Wilson: Caveman

Paul Wilson was a powerful man, over six feet two inches and spare build, but weighed 225 pounds. I have seen him more than once walking over the dunes from the highway with two ten gallon cans of gasoline for his boat, one in each hand. This means a walk of over a mile and a half. [118]
—Samuel Reck

Giant in stature, an eye like an eagle with revolver or gun, he was a man to be feared. [119]
—*the* Evening Messenger, *1923*

Paul Wilson was a man of remarkably tall stature, taller tales and a short, fiery temper. Like Alice, he shunned societal constraints and rules—an attitude that no doubt made them kindred spirits. Eleven years her junior, he was not as well educated as Alice, although his imagination was keen. Words often used at the time to describe the sand hills region—trackless, wild, untamed—also seemed to define Paul. His attraction to the dunes appeared to be driven by a sense of its lawlessness rather than any poetic interest in studying its environmental wonders. He was a local drifter who finally found among those wild sand hills a reason to stop wandering: Alice Gray.

During the seven years Alice and Paul lived together, they relied on each other, complemented each other's survival skills and remained consistently loyal in difficult, sometimes dire, circumstances. For his part, Paul dedicated

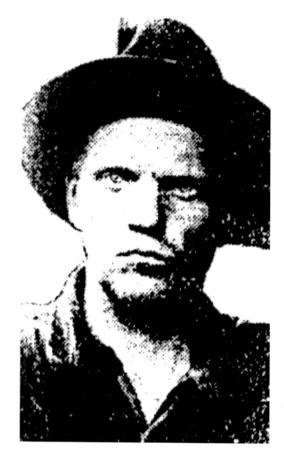

Paul Wilson. This version of his photo was found at the Westchester Township History Museum; the original publication and publication date are unknown.

himself to protecting Alice from outside intrusions and met their needs any way he saw fit—whether that meant through honest trades such as fishing, furniture making and building boats, or by petty thievery. The press often referred to him as Alice's Caveman. By most accounts, he adored her. That she welcomed him into her private enclave—and let him stay—took the eavesdropping public by surprise at every turn.

Written stories and oral histories describe Paul as an offensive individual with unusual strength, prone to disputes and outbursts involving neighboring beach dwellers and fishermen, local sheriffs and deputies and reporters. Paul waxed on about a Texas childhood made tragic by the death of his parents, causing him eventually to leave their home in San Antonio and take up the life of a drifter. In reality, his father, Otto Eisenblatter, was very much alive and living in Michigan City, although his mother, Caroline, had died on March 18, 1918, just a few months before he met Alice. After her death,

The True Story of Alice Gray

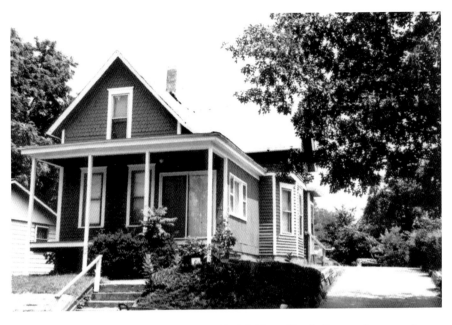

The childhood home of Paul Wilson, located in Michigan City, Indiana, as it appears in modern times. *Courtesy of the author.*

he became estranged from his family, which included two brothers and two sisters. The youngest child, Alfred, was just thirteen years old when Paul met Alice; two other siblings, Otto and Margaret, were nineteen-year-old twins, and his sister, Esther, was twenty-six.

All of the children, except Paul, still lived with their father at the time of the 1920 U.S. census.

Paul was born on June 25, 1892, and baptized the following August as Paul George Eisenblatter in the German Methodist Episcopal Church of Michigan City. He was reared for a time in a small frame house on Douglas Street that still stands today. Somewhere along the line and for reasons unknown, he dropped his family's last name.

At age seventeen, Paul was still living in Michigan City. Both he and his father worked at the Haskell and Barker Car Company, Paul as a "stenciler" and his father as a "riveter."

It's difficult to follow his path from that point, but a Michigan City native later said he served in the army with Paul in Texas.[120] Paul said he also lived for a while in Pennsylvania. When a newspaper reported in 1922 that his family had confirmed he had spent time in jail there, his father was compelled to write a letter to the editor denying that anything of the sort was said. "Such statements are unwarranted as none of our family have been informed as to

Paul's whereabouts since his mother's death several years ago and we do not know of him being in prison at any time.... As far as I know, such statements are mere neighborhood talk. Very truly yours, Otto Eisenblatter."[121]

Paul once claimed he was a rattlesnake hunter in Texas and another time said he was a prizefighter there.

In any case, Paul was twenty-six years old by the time he found himself back in Indiana. He might have heard about the strange woman called Diana of the Dunes, and, as a man who liked to spin far-fetched stories about his own history, Paul may have sought Alice based on the local gossip, admiring her odd independence. In a 1922 interview with a reporter,[122] he spoke of meeting her by chance, but at the time they first encountered each other he was roaming the beach near Alice's cabin—nearly ten miles from Michigan City, the place he once called home.

According to Paul's loose-knit story, he found his way to Indiana for the first time when he and another man traveled to Gary from Pennsylvania to find work in the steel mills, having done similar work in the East. When Paul somehow lost track of his companion, he disembarked the train in what he thought was Gary (Paul encountered another misstep getting off the South Shore train years later, one that landed him a jail sentence) but in retrospect decided it was actually the outskirts—probably the Wilson stop.

Seeing the lake and feeling tired and dirty, Paul opted to swim (noting to the reporter that he was a "good swimmer"). He dropped his "bundle," including the clothes he wore, on the beach and enjoyed a refreshing nighttime dip in the water, only to discover afterward that someone had stolen his clothes.

(Was it just coincidence that Paul surfaced in much the same way Alice did—swimming naked in Lake Michigan? Or did he fashion yet another tale, this time using bits of Alice's well-worn story?)

In the darkness, Paul said, he thought he had tracked the thief who nabbed his bundle, but he had mistakenly pounced on Diana while she was entering her shack. After a hasty explanation, they walked back to the beach and shared a long talk. He worked for a while at the nearby steel mill and then moved in with Alice just about the time he was arrested.

It was the couple's first separation—and likely their only one—when Paul began serving a six-month jail sentence late in 1918 for stealing from a handful of cottages nearby. Along with food and guns, he nabbed articles of women's clothing, including a winter coat. The path of his footprints, visible in rain-soaked sand, marked the trail from the scene of his last theft directly to Alice's shack, resulting in his arrest. Although the case against him was compelling,

The True Story of Alice Gray

Alice vehemently declared his innocence in a later recounting of the incident. "When those two men charged him with stealing, with only a bit of a wrist movement he could have laid them both away, but he knew that would prejudice the neighbors against me. So he took the punishment for my sake."[123]

In the course of the manhunt, Paul was shot in his right leg by Elmer Johnson, whose cottage had been burglarized. It was not the last time he would feel the searing pain of a bullet, although several years would separate the incidents.

Paul began serving his sentence at the penal farm in Putnamville, Indiana, in December of 1918. The previous winter had been the coldest on record for the region, but January through March of 1919 were comparatively mild, except for a brief period of drifting snow and high winds. Perhaps because Alice had experienced the harsh winter the year before—a frigid season of blizzard conditions that completely shut down lake commerce, as well as services in local communities—she sought temporary refuge sometime in the early months of 1919 at the home of Charles and Hulda Johnson. They lived along the Old Chicago Road, now known as Route 12, about a mile south of her shack.[124]

Just before she died at the age of ninety-four, the couple's daughter, Irene Nelson, spoke about living with Alice that winter. Nelson was ten years old when Alice became her family's house guest for about six weeks; Paul was incarcerated during this same time. The children always referred to Alice as Miss Gray, Nelson said, although her brothers teasingly referred to Paul as the Jailbird, rather than Mr. Wilson. He wrote letters to Alice from prison, which she received at the Johnson home. This would not have been unusual; throughout her first years in the dunes, Alice had her mail sent care of the Johnson address, according to Nelson.

For the most part, the family found Alice entertaining and pleasant.

"My brothers and I always said she made the best hot cocoa we'd ever tasted," Nelson said. Alice also amused the children by creating wonderful hand shadow pictures and plays on the wall. She might have stayed longer with the Johnsons, but a surprising behavior—one seemingly out of character for the Alice they knew—caused her premature, abrupt departure.

One late afternoon, Alice, Nelson and her mother were in the kitchen, Irene Nelson recalled. While Mrs. Johnson was busy at the stove, Alice began reading a personal letter just arrived in the day's mail. Suddenly, Alice let out an agonizing shriek and cried, "And I thought he believed in free love!"

The outburst disturbed Hulda Johnson, a devout Swedish Lutheran. She was appalled by the very idea and upset by the lack of discretion, as well as the intensity, of Alice's mournful wail.

With little hesitation, Nelson recalled, her mother turned from the stove and said, "Miss Gray, I believe it's time for you to return to your own home."

What exactly was meant by the words Alice so painfully read aloud remained unclear to Nelson, although she assumed the letter writer was Paul. Or was it? A persistent rumor was that Alice had run to the dunes three years before to escape a failed love affair. Her outcry over the letter occurred in the spring of 1918; the following summer, she would publicly settle the love affair debate once and for all.[125]

After she moved out, the Johnson family continued a neighborly relationship with Alice. She often bought bread, eggs and blueberries from Mrs. Johnson. "Miss Gray did not like picking blueberries, the bushes were too prickly," Nelson recalled. Stray folks who came looking for Alice (one would assume most of them were reporters, although Nelson remembered such visitors only as "friends") knocked on the Johnsons' door. Young and nimble, Nelson guided them through the woods, over the dunes and past the swamp areas—less than a mile from her house toward the lakeshore—and left her charge within sight of Alice's dwelling. Nelson never saw the cabin's interior, noting that Alice never let anyone else inside, either.

It seems unlikely that Alice received much in the way of mail after her first year in the dunes. Initially, she picked up small checks, installments for payment on book-editing work she had done prior to leaving Chicago.[126] Along with letters from Paul, written during his six-month jail term, there may have been a few notes from old friends still living in Chicago and perhaps some correspondence with her sister Nannie, who lived in Iowa, or her sister Leonora, who lived nearby in Michigan City, Indiana.

For all his wild ways, Paul was devoted to Alice. It was a mutual admiration. In an interview several years later, he described their relationship to a reporter: "Diana and I have been getting along like two kids. We never quarrel and have many things in common. She is what I call 'the truth.' I have the first time yet to catch her in a lie."[127]

At some point, Alice and Paul pulled up stakes at Driftwood and moved farther west to an area along Lake Michigan now known as Ogden Dunes. (An exact location of their cabin has not been verified.) Whether they built their own shack or Alice again co-opted an abandoned one is unclear. It seems likely that the move took place during the summer of 1918, soon after Paul finished serving his six-month jail sentence. He claims they took a slight detour before settling down. "Diana stuck to me through it all. After I got back, we took a little trip to Knoxville, Tenn., where we were married. We came back to the beach shortly after that, and have been living here ever since."[128]

The True Story of Alice Gray

Wren's Nest, the Ogden Dunes home of Alice and Paul. The cabin was destroyed in 1925, but its smokestack was reportedly present until the early 1930s. This photo is from the *Gary Post and Tribune*'s June 19, 1922 edition.

The couple never legally married, but later mentions refer to their "common-law" marriage. They named their new abode Wren's Nest.

A later news account about their relationship describes the chores Paul did for Alice, including catching fish, gathering wood, foraging for the daily menu, repair jobs and "other man-sized duties and burdens which she shouldered."[129] The author took care to note that Alice continued to help in these pursuits and mentioned that, on rare occasions, the couple took sightseers out on their fishing boat.[130]

Paul relied on Alice to make visits into town for food and supplies; he seldom traveled far from the beach.

What he did not know about the dunes, Diana taught him from experience. He soon knew every inch of the dune country, from Ogden Dunes, past Waverly Beach to Michigan City. He was an expert guide and could tramp the dunes with his eyes shut.[131]

The same year Alice and Paul moved into Ogden Dunes, Camp Win-Sum—built by the Boy Scouts—rose up a block west of their shack. The campers made use of two sturdy rowboats built for them by Paul, but for

the most part interaction was limited. The lack of contact was enforced by a Scout rule barring the boys from visiting Wren's Nest: "Heavy penalties were inflicted on Scouts who violated the rule, like a week of K.P. duty. However, Diana and Paul didn't observe the same rule, and often a large supply of food would be reported missing from the camp's larder."[132]

Despite such claims, after the petty theft charge for which he was jailed, Paul steered clear of real trouble—that is, until the summer of 1922 when a violent incident in the dunes showed just how brittle their stake in the sand hills had become.

Murder in the Dunes

The Dune land is becoming such a live spot, that all the Chicago newspapers have reporters on the ground.[133]
—*the* Evening Messenger, *1922*

Alice and Paul quietly disappeared from the public eye for nearly two years. That is until the disturbing summer of 1922, when the bonds of neighborly existence in the dunes—worn thin by earlier rifts—simply snapped. A gruesome death in the sand hills near Waverly Beach again attracted hungry reporters. They scurried for clues, but also for culprits, most notably Diana of the Dunes and her Caveman, Paul Wilson.

Banner newspaper headlines ran rampant across regional front pages for nearly a month, boldly linking the dunes couple to the grisly mystery despite a complete lack of tangible evidence. The deleterious stories outraged Alice; the unfolding events battered her both physically and emotionally. This frame of publicity, more than any other, haunted Alice to the end of her days.

While hiking in the dunes on Thursday afternoon, June 8, 1922, a Chicago college student stumbled upon a horrific scene. He encountered the charred body of a man lying prone over a smoldering pyre, the remains badly decomposed and unidentifiable. A front-page story in a Valparaiso, Indiana newspaper described in graphic detail what the young witness reported: "This stranger turned a gastly [*sic*] white to see laying in the center of the charred log remains, the human bones of a man, with the arms sticking straight up above

his head. All the clothing had been burned up, the flesh completely consumed, and maggots and worms were working on the remains."[134]

Porter County's coroner and sheriff combed the sandy locale for clues, but their search uncovered little information. They placed the victim's death about ten days prior to the discovery of his body. Belongings found at the scene—a suitcase with a small amount of foodstuffs, new clothing and petty cash—proved more baffling than helpful. The suitcase was marked "Anderson," but several purchase receipts found for the clothing indicated a different name. A discarded jar used to carry gasoline and a rifle, both deposited near the man's head, were the only other solid evidence agreed upon in published reports, although other items such as camping gear, a radio and a blood-soaked newspaper crumpled under the victim's head immediately became part of the local lore. Was it suicide? An accident? Murder? The evidence was lean enough to suggest all three, but murder quickly became the focus.

As the newspapers explained it, Alice and Paul became prime targets for questioning because the general public had not seen the couple for some time. The search for them had as much to do with Paul's shady reputation as Alice's mystique; nonetheless, the unexplained disappearance of Alice had obviously unsettled the beach community. Although by 1922 she had lived in the dunes for seven years, the immediate suspicions of her neighbors indicated a lingering undercurrent of wariness where Alice was concerned.

For her part, Alice would not accept lightly what she viewed as betrayal. A Gary newspaper chronicled the hunt "throughout Duneland" for Alice, and her response:

> *"Diana of the Dunes," the strange woman who has been a familiar figure among the Dunes since 1916 when she left her studies at the University of Chicago to take up a half-barbaric life in the sand hills, was located late yesterday and denied all knowledge of the man's death. Authorities started a search for her when it was found that neither she nor her husband, Paul Wilson had been seen for several weeks.*
>
> *She made the following statement to reporters: 'I have long been considered the romantic property of the press, and I have been given a lot of undesirable notoriety. I have refused to profit by it, but I see no reason for mentioning my name, or that of my husband, in this investigation. My husband is not an ex-convict, as has been reported.'*[135]

At least eight Indiana newspapers reprinted, in full or part, a copyrighted story in Chicago's *Herald Examiner*. On Saturday, June 10, 1922, it ran under

The True Story of Alice Gray

the original front-page headline in large, thick type: "'Diana of Dunes' Being Sought in Slaying Mystery." The article said the dead man had been found "near Driftwood"—the couple's former shack—and that a fisherman reported Paul "recently was seen putting ashore at Waverly Beach, a short distance from where the body was found." Posses, the article went on to say, "sped through the tractless wastes of the dunes all of yesterday seeking 'Diana of the Dunes' and her cave man."

But a subsequent news item in Valparaiso's newspaper forcefully denounced the accuracy of the Chicago story:

> *The writer obtained for his paper, the most distorted conglomeration of facts that it would be possible to get, and to the people here who know the facts on the case, the story is ridiculous. He likened Diana of the Sand Dunes with the mystery, as well as her "cave man," both of whom have been gone from the vicinity for months. It was also stated that the dead man had a tent and complete camping outfit, as well as a radio set at the tent, and referred to his death as the radio mystery. The facts are that he had no tent, no sleeping blankets, or camping equipment, and no radio set.*[136]

The wildfire of rumor and innuendo dragged on for weeks, fed by prolific reporters digging for any new details. For all the reporting, there was never any supposition in the news stories as to why Alice and Paul had disappeared prior to the incident—for however long their absence really lasted. (Newspapers reported it was anywhere from a matter of days since anyone had seen them to several weeks or months.) The press linked the couple closely to the event by insinuating they would certainly know something about it—that is, if they weren't directly involved. By most accounts, however, the incinerated body was discovered at least five miles east of Alice's former shack, Driftwood, and likely even farther away, based on bits of information gleaned from news articles. During questioning by the sheriff, Alice and Paul apparently accounted for their whereabouts the previous week by producing a diary of their activities, particularly during the time of the alleged murder. The newspapers, however, did not note their specific alibis.

Adding to the speculation, it was reported that the dunes couple had been seen in the vicinity of the crime. One newspaper pegged the informant as Elmer Johnson:

> *Diana telephoned the sheriff yesterday asking if she were wanted and saying she is willing to surrender at any time. The sheriff told her that she was not wanted.*

Diana of the Dunes

> *Wilson, who was shot in the leg by Johnson last year, is said to resent the latter's report and is said to have announced he will settle the score.*[137]

On Sunday, June 11, authorities said they had identified the dead man as a nineteen-year-old bank clerk and vaudeville actor, based on information confirmed by his brother. By the next day, however, the alleged victim had stepped forward to proclaim that he was, in fact, still very much alive. A page-one newspaper photograph[138] showed him standing before his own purported funeral pyre.

A local taxicab driver added more intrigue by claiming that near the time of the supposed murder, he drove a woman from a South Shore train stop to a place in the dunes near the site.[139] She seemed anxious from the start and asked him to wait. When she returned forty-five minutes later, the woman was hysterical; so distraught, in fact, that the driver suggested a doctor. She refused the offer and boarded a train back to Chicago. Was this mystery woman the murderer? According to newspapers, the Chicago police received a description of her from Indiana investigators, but the puzzle of her identity was never solved.

In the meantime, hostility simmered between Chicago investigators and local authorities. Porter County's sheriff and coroner had immediately buried the victim in a wooden box in the sand at the site of his death—meaning to keep his interment intact until they solved the crime. However, within a few days, Chicago reporters brought a doctor to the dunes. They exhumed the body in a secret midnight rendezvous, with the aid of lit torches, but only after shaking off a rival reporter during an automobile chase through town. The raiders snatched the jaw bone and parts of the skull from the body and then raced back to the big city. A deputy-coroner from Chicago conducted an unofficial postmortem, paid for by a Chicago newspaper.

Outraged, Porter County's coroner later threatened a lawsuit, but he never filed one, perhaps because some investigative good resulted from the underhanded tactics. Based on the added clues garnered from height, weight and jaw measurements, along with the dental structure of the victim, the local sheriff discounted more random claims, suspects and evidence—and eventually, too, the involvement of Alice and Paul.

While newspapers gained fresh fervor with each breaking theory, reporting continued to link Alice and Paul to the mystery. Paul's criminal record and his reckless relationships with other dunes dwellers surfaced in stories designed to cast further aspersions and whip up sensationalist talk. As the weeks wore on, Paul's alleged misdeeds and tall-tale alibis gathered like sand drifts at the couple's door.

Fed up, Paul and Alice sought to douse the flames of suspicion. Their actions, however, only added to the chaos of the case. They paid a visit to

The True Story of Alice Gray

Heralds of the Storm, etching by Earl H. Reed and published in his book, *Voices of the Dunes*. Courtesy of the Westchester Township History Museum.

"Fisherman" Eugene Frank, a deputy sheriff and also a hired watchman for cottages along the lake. He had a history of trading heavily in rumors about the couple; Frank even led sightseeing excursions for Chicago curiosity seekers to Alice's shack, touting her as a famed recluse. Paul often warned him to stay away from Wren's Nest, especially when he wasn't around, but the threats did not stop Frank's ventures.

Adding to Paul's fury, Frank also told beach residents that Paul habitually robbed fishing nets and cottages, news that reached Paul through a fisherman by the name of Elmer Johnson—the same fisherman who shot Paul in the leg for stealing from his cottage several years before, and who told the sheriff he had recently seen Paul in the vicinity of the crime.

On the evening of June 14, 1922, Paul and Alice resolved, finally, to confront their tormentor. Whether the couple knew to expect violence or not, their attempt to quell the ugliness only brought them greater agony.

If Alice gave a public accounting of what happened that night, her story never made it into print. Two years later, however, she described the injury inflicted on her by Frank, along with the subsequent physical and financial costs, in a legal brief.[140] Frank, she stated, struck her on the head "with a heavy revolver, thereby

crushing her skull so that she was wounded and unconscious." Alice said she "hovered between life and death for a period of five days." The cost of surgery and postoperative care, she noted, was $150, plus additional "hospital services" in the sum of $127. During her hospitalization, Alice "suffered great pain," and as a result of the wound, "her head is disfigured," she wrote.

The same legal document noted that Paul, who was making ten dollars a day building boats, was "totally disabled" from work for about two weeks and "partially disabled" for another two weeks.

While Alice's story was revealed only in court documents dated two years after the fact, Paul's vivid recollections of the incident with Deputy Frank were recounted in the press when it happened:

> *When we arrived at the fish house of Frank's on the beach, I rapped on the door and knew at once that he had been drinking. He started to yell, called my wife a rat and myself vile names. When he pushed me back I stepped off the porch and he reached in the fish house and got his gun.*
>
> *My wife stayed on the porch, and on the porch again he told me to throw up my hands which I did and he shot me in the foot. My wife, seeing this, stepped up and he hit her at my feet and when I tried to pick her up Frank told me to straighten up or he would kill me.*
>
> *He then had his son go get a rifle and the other son a horse and then marched us to the pavilion where he called the police patrol.*[141]

The deputy recalled differently: "According to Frank's version of the trouble, Wilson came to his house looking for trouble and as soon as he got to the house Wilson grabbed him and then his wife Diana pitched in. He stated he struck Diana and shot Wilson only in self defense."[142]

By all accounts, Frank was merciless that night. Paul offered the most vivid description of Alice's wound: "If I had gone there with the intentions of having trouble I would have carried my gun, knowing that Frank's shack is covered with them. I went there unarmed. He struck my wife with the butt of his gun, caving in her skull as big as half my hand, and I haven't a damn small hand."[143]

The injuries Frank inflicted on Paul and Alice were of no consequence to him when he hitched up his horse and made the couple hike, as best they could, west toward the Miller police station, along a two-mile stretch of night-soaked beach. Each painful, uneven step in the shifting sand must have pierced more deeply the darkening spirits of Alice and Paul. "When I tried to go to my wife's assistance, Frank threatened to shoot her. He made us walk 20 feet apart," Wilson said.[144]

The True Story of Alice Gray

A postcard, dated 1923, of Mercy Hospital in Gary, Indiana, where Alice Gray recovered after a deputy sheriff fractured her skull with the butt of his gun. *Courtesy of the author.*

At the Gary jailhouse, Paul received superficial treatment for his gunshot wound and, along with Frank, endured several hours of questioning about the incident. Authorities rushed Alice to Mercy Hospital in Gary, where she underwent emergency surgery for a severe skull depression. She remained bedridden there for several weeks, a fateful isolation that may have begun a bitter unraveling of her dunes life. There were dire reports that Alice was dying; other accounts were more matter-of-fact.

Again in large, bold type, banner headlines screamed the news of her injury: "Diana Hurt in Fight on the Beach," "Dunes' Diana in Hospital Badly Hurt," "Diana of Dunes Mixes in Fray," "Diana of Dunes Victim of Brawl" and "Dunes Diana's Skull Broken."

But Paul had not had enough excitement for one evening. At the Gary police station, he related a story about a strange man he felt sure was somehow connected to the murder. The authorities, despite knowing full well Paul's proclivity toward storytelling, embarked on a wild chase through the dunes to find the man. "A squad of Gary detectives and police, armed with revolvers, sawed-off shotguns and searchlights, were speeding toward the sand dunes between Miller and Waverly beaches as the *Post and Tribune* goes to press this afternoon, determined to solve the mystery."[145]

They were searching for Thomas Burke, who had apparently threatened the couple. The incident happened after a rough night of boating on the lake, when they were caught in a wild storm, according to Paul. Having finally reached shore, they fell into a sound sleep but awoke suddenly to a bizarre scene. He described it this way:

> *Six candles had been arranged at my side in a row. A coil of rope lay at my feet and another coil at the feet of "Diana." A man stood in the doorway of our hut, outlined against the flashes of lightning.*
> *I saw he held a revolver in each hand.*

The man accused me of trying to drive him from the dunes and said he was going to kill both of us. I tried to argue with him, but he turned and disappeared into the darkness.[146]

Paul managed to convince authorities that Burke could be the victim. Evidence never materialized.

As if things weren't already spiraling downward, looters ransacked the couple's shack during the brief time that Paul remained in custody. Clothes, furniture and books disappeared, but the most severe blow to Alice was the theft of her manuscripts. A Gary newspaper blamed "Chicago reporters, curiosity-seekers and alleged thieves" who helped themselves to "practically everything of value."[147]

Alice and Paul would later accuse "certain officers of the law and deputies" for the raid. They claim the authorities, who were seeking evidence that the couple was involved in the murder, carried off her manuscripts, as well as her six-year diary; Paul's boat-building tools (which they valued at $400); and "other personal belongings, namely: one wrist watch; one shot gun; one Kodak; one field glass and numerous other articles of the approximate value of $200."

The place was left in such a shambles that Paul couldn't sleep there. He went to the nearby Boy Scout camp to spend the night—and while he was there, the shack was ransacked again, but there was nothing left of value to steal.[148]

There is no mention of any recovery of the stolen items, although a later article claimed that personal items stolen from neighboring cottages were found in the cabin.[149]

The sheriff charged Frank with shooting with intent to kill; Paul was charged with assault and battery. Originally scheduled for June 21, 1922, the case was continued until June 29 because Alice remained in the hospital. A news item reported that the Crown Point, Indiana grand jury would review the case.[150] But the trial never took place. Alice and Paul did not show up for the initial hearing, claiming they had not been notified that it was to take place. Two years later, Deputy Frank died in a horseback riding accident—before the grand jury heard the case.

The entire episode of the summer of 1922 took an immense toll on Alice. The fierce speculation, the combined physical and emotional trauma and the lack of neighborly regard proved too much to reconcile.

A Case of Libel

Diana was one of the most unique characters that has ever gained public eye. All sorts of periodicals and newspapers wrote columns about her elfing life on the shores of Lake Michigan, sometimes grossly enlarging so that she finally became embittered against newspapers and reporters and of late refused to be interviewed.[151]
—*the* Evening Messenger, *1923*

As the summer of the sand hills murder mystery waned, Alice—most likely with a bandage still covering her head wound and still feeling weak—visited Hammond, Indiana. She scouted for a lawyer and vowed to sue the Chicago newspapers for libel. But it would be two years before she finally acted on this threat.

In the meantime, the region was busy road building. With great fanfare, the new Dunes Highway (now U.S. 12), a marvel of engineering begun in 1920, finally opened in November of 1923. Long parades of cars, a band playing patriotic music, banners, speeches by officials of three states—Indiana, Michigan and Illinois—a bronze plaque and receptions marked the dedication of "the greatest highway in the United States," as viewed by "thousands," according to the *Gary Post-Tribune*.[152]

Another local paper characterized the initiative and collaboration between cities:

> *Conceived within sight of prison walls at Michigan City, fostered by the steel city of Gary to the west, opened with a corkscrew and dedicated in a hail storm—the Dunes highway between Michigan City and Gary is now open*

DIANA OF THE DUNES

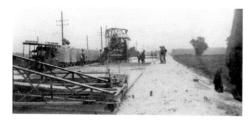

Postcard view of construction on Dunes Highway (now U.S. 12) at the former Dune Park stop in 1923. *Courtesy of Westchester Township History Museum.*

to traffic. The most important link of Indiana hard-surfaced highway, connecting the West Michigan pike of Michigan with Chicago, through Michigan City and Gary, represents an investment of a million dollars.[153]

That was on a Friday. The following Sunday, Gary traffic officers reported that twenty thousand automobiles passed along the route, mostly from Illinois, although the license tags represented more than a dozen states.[154]

Another project, the excavation of the main channel at Burns Ditch, connecting the Little Calumet River and Lake Michigan, was also underway. The machinery for the project was to be unloaded and corralled at Dune Park, near where Alice had first arrived in the dunes eight years before.[155]

During all the construction and commotion, Alice and Paul felt keenly the threat of progress while attempting to maintain their dunes life. The press had left them alone since events of the murder mystery. In the summer of 1923, however, it found something else to write about, albeit a minor blip on the Alice radar—and again, Paul was in the limelight. He was arrested and "taken" for fishing without a state license. The Giant of the Duneland was fined twenty-four dollars and released on his birthday.[156]

One week after the opening of the highway, Gary's newspaper announced that "'Diana of the Dunes' and her mate" had fled their shack; they had been planning the trip for a while. The couple left the dunes in a twenty-foot open boat, fashioned of found parts, bound for Texas, with near-freezing temperatures in the local forecast. "In a made-over motor dinghy salvaged from the wreck of a steamship lifeboat that floated to the beach near their isolated shack at Ogden Dunes, east of Gary, the two are floating down the Mississippi River, bound for their great new adventure."[157]

Alice and Paul blamed their departure on encroaching civilization. The dunes region was quickly growing in popularity; new roads from Chicago brought increased tourism and encouraged the building of sturdy, permanent homes in year-round beachfront communities. The squatters' shack they inhabited was no longer private—worse, a developer decided the structure should be demolished, and sooner rather than later if he had his way.

The developer, Samuel Reck, was creating a beachfront community in Ogden Dunes where "fine suburban homes" were to be built. Alice and

The True Story of Alice Gray

Paul's shack sat on his property. Reck saw the two off on their journey; he had a vested interest in their leaving. "Besides, the romantic squatters who have filled columns of newspaper and magazine space since they decided to lead the simple life, untrammeled, in the then wild dunes region, were served with a notice to get off of the desert by the Ogden Dunes company upon whose property they had reared their humble abode."[158]

It was a long time coming, this departure. Since the murder accusations, followed by the physical and emotional trauma of her head injury, Alice had lost a great deal of the innocence, the idealism and the vitality of a dunes spirit that had guided her through rough times before. It became noticeable to those who had followed her over the years she spent in the dunes: "To the observer who sees Diana these days with the physical eye only, much of the romance in connection with her determination to leave the comforts of home and school and live a lonely life in the hills and vales of northern Indiana has departed."[159]

But "much of the romance" of the press remained intact. "Wilson will go back to his former business of catching rattlesnakes in Texas, it is said, and Diana will tramp the deserts and plains of the 'Lone Star' state with him and be just Diana, and that is sufficient to Paul."[160]

Although an explanation is lacking, for some reason the escape plan did not work out. Six months after leaving the Indiana dunes, Alice and Paul returned to Wren's Nest, their shanty home in Ogden Dunes. Fortunately, Reck had not gotten around to leveling it, as he had planned.[161] He allowed them to move back in.

Amid the flurry of house and road construction, Paul's boat-building project and their subsequent flight from the sand hills, the couple's fury over news stories published two years before that linked them to the murder had not dissipated—rather, it had continued to fester. "During this summer Diana stayed more closely to their shack. We saw her occasionally. She was busily engaged in writing. They were much concerned over bringing a libel suit against some Chicago papers against which they bore a powerful hatred."[162]

After a span of eight years of sensational headlines, on June 9, 1924, Alice finally pushed back against the press. With the help of a young attorney from Hammond, Indiana, Timothy Galvin of the Galvin & Galvin law firm, Alice and Paul filed a libel suit against the Evening American Publishing Co. (owners of the Chicago American) and the Tribe of K. (distributors of the newspaper) in the U.S. District Court of Hammond, Indiana.[163] "They claim the articles in the Chicago paper contained false and malicious libel and defamatory statements reflecting on the character of the couple."[164]

According to the legal documents, a front-page headline in the Chicago American, published June 9, 1922, read, "Death Mystery in Dunes"; the subtitle

read, "Charred Body Found on Funeral Pyre; 'Diana' Sought." Headlines above a second story, which ran on page two, were equally damning, the suit contended: "'Diana' and Cave Man Sought in Dunes Slaying Mystery," with the subtitle "'Diana of the Dunes' Incarnate Spirit of Wild Waste of Sands."

Prior to filing the libel suit, Alice and Paul demanded that the Chicago American publish a retraction "in as conspicuous a place and type in the same place where said original article appeared."

In a Notice of Retraction,[165] which Alice herself delivered to "City Editor Maloney" on June 5, 1924, the couple set forth their objections:

The libelous matters contained in said article being that Alice Gray Wilson, named by your paper as "Diana," was sought in connection with said alleged death and was connected with and accused of said death and that she met all comers with a revolver and that she went about in unconventional bathing garb and that it was not safe in the neighborhood where she lived and that she was a dangerous and disreputable person and was living with Paul Wilson and not married to him; all of which statements were false and libelous.

They also objected to the published description of Paul:

[He was] known as a tough character in the vicinity of Chesterton and nearby towns and served six months' time in the penitentiary and honor farm and was charged with theft of fowls, butter, eggs, etc, and was accused of being connected with the alleged death mystery in said article and sought for questioning thereon and that he was a bad and dangerous character...all of which is wholly untrue, false and libelous.

Damages were sought from the publishing company and its distributor in the amount of $100,000. The amount included medical fees incurred by Alice and Paul as a result of their run-in with Deputy Frank, which they felt was precipitated by the newspaper stories, and injury "in their reputation, in their person, in their characters and in their property."[166]

But, just as Alice was denied the opportunity to have her say in court involving the lawsuit against Deputy Eugene Frank, in this case, too, she never got the chance to face her newspaper adversaries. On April 14, 1925, Galvin petitioned the court to dismiss the libel case.

And again, the press confounded the facts: "The death of Alice Gray, 'Diana of the Dunes,' who lived in a shack in the Indiana sand dunes, automatically ends a million dollar libel suit pending in the United States District Court."[167]

In the End

Alice Gray Wilson—to uncounted thousands, "Diana of the Dunes"—is dead.[168]
—*the* Evening Messenger, *1925*

Throughout the day on Sunday, February 8, 1925, the weather was unsettled outside Wren's Nest. Shifting winds prevailed, and the already cold temperature was expected to drop. Rain or light snow was forecast for the hours after dark. Icy foam marked the shoreline of Lake Michigan, while ice floes dotted the wild waves. In the midst of yet another difficult winter, Alice Gray lay seriously ill on her pallet, as she had for nearly a week, refusing medical treatment. Sometime late in the night, she slipped into a coma.

Frantic, Paul finally left Alice's side to run for help. He knocked on the bedroom window of developer Samuel Reck, the nearest neighbor who owned a car, to waken him and ask that he fetch a doctor.

Reck dressed immediately and headed into Gary, where he picked up Dr. DeLong. The sand was still so frozen he could drive his car on the beach and park close to Alice and Paul's shack, thereby saving valuable time traipsing across the dunes.[169]

The doctor diagnosed Alice with uremic poisoning (kidney failure) and treated her with hot water bags and "stimulants." Despite his best efforts, she did not regain consciousness, so Reck and DeLong went back to Gary for additional medicine. That too, was ineffectual. After several more hours of bedside vigil, Alice died the morning of Monday, February 9, just before dawn. She was forty-four years old.

DIANA OF THE DUNES

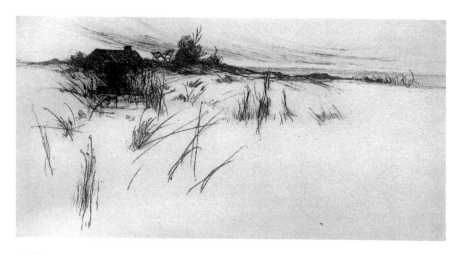

A Fisherman's Home, etching by Earl H. Reed and published in his book, *Voices of the Dunes*. Courtesy of the Westchester Township History Museum.

The news spread quickly and with nearly as much imaginative reporting as when Alice was first discovered in the dunes. Within two days, newspapers across the United States reported her death by featuring variations of stories printed by dunes-area and Chicago newspapers. Among others, readers in Montana, Michigan, California, Nebraska, Tennessee, Connecticut, Pennsylvania, Iowa, Wisconsin, West Virginia, Virginia and Texas read about Alice's last days, whether they had previously known her story or not.

The national headlines ranged from the straightforward, "Diana Dead,"[170] to the romantic, "Diana of Dunes Is Dead, Dancing in Moonlight on Sands of Shore at End."[171]

A sampling of headlines written by local editors highlighted their favorite details from a long history covering Alice: "Diana of Dunes Reported Dead in Her Lonely Shack," "Mystery Woman of Dunes Dies," "Earth Claims Diana's Body," "Diana of the Dunes Dies at Her Little Shack Nestling in Duneland," "Diana, Dunes Nymph, Is Laid to Rest in Oak Hill; Friends to Donate Flowers."

Even the venerable *New York Times* published a six-paragraph article on the life and death of Alice, under the headline and bold-typed subheadline, "Diana of the Dunes Dies of Privations: Chicago Woman Who Took Up the Primitive Life in 1916 Refused Hospital Aid."[172]

Almost every news account featured two simultaneously tragic and romantic notions. The first was that Alice died in Paul's arms. In one example, a headline printed on the front page, top fold of the *Syracuse Herald*

The True Story of Alice Gray

read: "College Honor Student, Who Led Cave Girl Life, Dies in Giant Mate's Arms."[173]

The second theme helped set the foundation for later ghost stories about Alice. Her one fervent wish, often expressed to Paul while she was living, so he claimed, was to be cremated—her ashes scattered on the northwest winds from the majestic dune called Mount Tom. Located at then Waverly Beach (now Indiana Dunes State Park), Mount Tom is the highest dune in the region. But cremation was unusual and therefore expensive and, even then, available only at some inconvenient distance from the dunes. Paul had no money but attempted to follow through on his promise by beginning to build a funeral pyre on Mount Tom—until Samuel Reck convinced him to let Alice's family have their say.[172] Ultimately, the family took over planning the funeral arrangements and refused to allow cremation.

One local newspaper article put it bluntly: "Diana of the Dunes is to be buried quietly and 'horribly respectably' late today from a little undertaking parlor in the sooty city of Gary."[175]

A brief obituary published in the March 1925 issue of the Prairie Club bulletin was sympathetic to Alice's struggles and kind in regard to the woman they had known:

> *A Tragedy of the Dunes*
> *With the death of Mrs. Paul Wilson, long since printed the woman of mystery, "Diana of the Dunes," the curtain has fallen upon a tragedy whose stage was our own Duneland. Formerly Miss Alice Gray, a brilliant science scholar, a Phi Beta Kappa graduate from the University of Chicago, and an editorial secretary of accomplishments, her pleasant voice is well remembered by those with whom she dealt, and her fresh spirit and fair-mindedness left its impress, incorrigible individualist though she was. What cataclysm led her, ten years ago, from academic walls to the shelter of inclement skies and a shack on the wildest portion of the Dunes, we do not know. She lived alone summer and winter in the Dune wilderness, but finally received odious publicity through some avid sensation-monger. Her life for a time was shadowed by various conflicts with the society she had tried to escape.*
>
> *She knew and loved every native plant and animal, every mood and color of lake and dune. Three years ago she married Paul Wilson, a native son. Early in February she died, after a short illness, among her loved sands.*

The funeral attracted the public eye, and not surprisingly, newspaper details of it vary. Just one story reported that schoolchildren brought flowers

to place on her grave.[176] The fact that Paul brought a gun, however, is consistent throughout the retellings.

As her body lay in a parlor of the Williams and Marshall funeral home in Gary, Reck recalled,[177] a crowd of curious people gathered outside, while a smaller group of relatives and friends sat on benches inside the chapel. Reck sat next to a visibly grieving Paul, who was alone in the back of the room. He noticed that Paul's hand was covering a revolver in his pocket.

The funeral, which began at 2:00 p.m., was presided over by the Reverend James Foster, rector of Christ Episcopal Church. It was brief.[178] As those in attendance made their way forward to view Alice's body before the casket was closed for burial, Paul joined them. At the sight of her, he dissolved into a grief-stricken spate of shouting, drawing his gun and waving it in the air above Alice's bier. Two people said he yelled a threat, although they each heard something different.

One of them heard, "Diana, I'll get that damned newspaperman!"[179] The summer before she died, Alice was busy preparing for her libel case against the Chicago newspaper company,[180] which was set to be heard in the spring of 1925. The pall of accusation had hovered over them for two long years, and the couple was anxious to have their say. But Alice's death effectively ended the lawsuit.[181] Paul—acutely aware that the news coverage of the 1922 murder had devastated Alice and weakened her not only spiritually, but physically—was wracked with resentment.

A second threat from Paul—"Anyone who takes her body will be sorry!"—was also reported.[182] His frustration with his inability to fulfill her wish to be cremated, her ashes cast from atop Mount Tom, would account for such a wild outburst. As it happened, he did not see her buried in the Gary cemetery, either.

Still waving the gun, Paul pointed it at Alice's nephew, Chester Dunn, the relative who signed her death certificate and paid for the funeral.[183]

But Paul gave up passively when the authorities arrived. He was escorted to Gary's police station and held for a short time. Once his Diana was laid to rest at Oak Hill Cemetery, Paul was freed.

The memory of her, and the plans they had made to leave the dunes region and move to Texas, haunted him. Paul supposed he would make the trip alone, but he wasn't making any promises. He was literally lost without Alice.[184]

Reck left little choice for Paul; he had to make some sort of move. Just days after Alice's burial, Reck cut Paul loose. "We agreed that a good revenge on the curious would be to burn down the shack and remove all traces of it.

The True Story of Alice Gray

When he agreed, I carried out the destruction of the shack at once, having no desire to harbor a wild man on the property."[185]

But for another decade, a single, visible trace of Wren's Nest would remain:

> *After this, Paul and Mr. Reck burned and destroyed the last vestige of one of the most romantic episodes in the history of Ogden Dunes. No, not all, for still to be seen in the hollow where the couple lived is the twenty-two-foot steel stack of a tugboat that served as a chimney. To see this is to fill one with awe at the strength of the man who placed it there. To visit this spot on a quiet moonlit night is to make one wish history could turn back and permit one to converse with this couple who knew and loved the handiwork of Nature as she was to be found here in Ogden Dunes.*[186]

Eventually, Paul became embroiled in other adventures that landed his name in the columns of newspapers; but after Alice died, his free-spirited life in the dunes ended without reprise.

Afterword

Although Alice Gray died in 1925, we still tell her story today for myriad reasons; each version suits a purpose. We rework and refine details, winnow facts and dismiss them at will, follow a thread, create a new weave. The story's ultimate design depends on our audience, our level of interest and curiosity, perhaps the time of day—are we camping around a late-night beach fire telling ghost stories or visiting the local museum on Saturday afternoon?

As much as anything, historical relevance keeps Alice's story alive. The last decade of her life spanned a broad and important era in dunes history, one in which efforts to preserve the region's world-renowned environmental treasures clashed with the plans of steel-mill barons and jobseekers. Before those years, Alice lived in the early days of an industrial Chicago bursting at its seams, followed by a time when the city shared a cultural tapestry with the neighboring Indiana dunes through well-known characters such as sculptor Lorado Taft, poet Carl Sandburg, painter Frank Dudley and landscape architect Jens Jensen.

Alice's story also highlights a time when the political activism of women claimed front-page headlines in defiance of second-class citizenship. It is easy to admire her self-liberation from the strict and confining roles defined by society.

Alice Gray set out to rediscover herself when she left Chicago on a South Shore train bound for the remote sand hills of Indiana. In telling her story, we reflect on how both history and our own standards judge the success or

Afterword

failure of her journey. Her intentions are suspect, too, even now. Should Alice have left Chicago at all? What reason would we find most acceptable: a love affair gone sour, illness, rebellion against a male-dominated society, a chance to prove her self-sufficiency? Was she mentally ill or merely formidable in deciding to live alone in the dunes? Was Paul a soul mate, a bodyguard, a menace? Did she appear friendly enough and proper, or was she morally bankrupt and too self-righteous?

This is also the story of a woman with romantic dreams thwarted and her dogged determination, in the face of that corruption, not to give in or relent when tides of objection rolled in. To study Alice Gray is to learn about digging our toes in the sand and standing firm, despite the inevitable shifting that takes place beneath our feet.

Alice Gray loved the dunes region; she sought to explore it, to document the wonders intrinsic in the landscape. She wished to experience that natural artistry by melting into it—at the same time, nurturing her own wild roots. While the process may not have been fluid or graceful, Alice must have succeeded. For all she may have suffered or left behind, she also gained a truer sense of Alice Gray, her limitations and her potential, her ghosts and devils, her needs and desires. Alice could not help but find what she was looking for, although her search did not play out according to some original, romantic plan.

Writers of Alice's story have claimed that she sought solitude, finally achieving her hard-fought peace only in death. At first glance, there is little reason to argue this point. The press was indeed intrusive in its business of myth-making, especially where she was concerned. However, digging deeper into Alice's life both before and during the dunes years, it seems more accurate to conclude that she did accomplish what she set out to do when she left Chicago, bound for the sand hills along Lake Michigan's southern rim. In the end, she lived on her own terms, setting parameters by lifting them, fiercely guarding her door against those who would attempt to beat it down. For all the public scrutiny, there must also have been ample periods of solitude and time enough to reaffirm her decision to stay.

The dunes stretch both wide and deep, traversing from open shoreline to sand hills to dense forest. The region is both harsh and forgiving, depending upon the season and upon one's will and innate strength of character. It was easier to get lost in those sand hills than one unfamiliar with the landscape might think. Alice learned to navigate the terrain, circumvent the realities of weather extremes and glorify the spare rewards of living simply. It was the human connection that kept tripping her up; reporters, fellow beach

Afterword

dwellers, townspeople—Alice often found herself in their relentless glare. Little wonder, then, that the poem that inspired her to seek a new life among the sand hills contains these lines:

CLXXVIII

There is a pleasure in the pathless woods,
There is a rapture on the lonely shore,
There is society, where none intrudes
By the deep Sea, and music in its roar:
I love not man the less, but nature more,
From these our interviews, in which I steal
From all I may be, or have been before,
To mingle with the Universe, and feel
What I can ne'er express, yet cannot all conceal.

"Childe Harold's Pilgrimage: Canto IV"
Lord Byron

Appendix A

Siblings

Leonora

When Alice was just five years old, her eldest sister, Leonora "Lena" Gray, married Ernest G. Dunn, who was born in England and made his living in the lumber business. After their marriage in January of 1886, the couple moved north to Muskegon, Michigan. By 1896, they had settled into a home on Spring Street in Michigan City, where they raised a family of eight children. Death took two of their children in young adulthood.

The couple's eldest daughter, Emma, died suddenly, at age twenty-six of Landry's paralysis. She was a beloved first-grade teacher in a local school and had retired six months before her passing in order to prepare for her upcoming wedding. On January 10, 1912, the *Michigan City News* reported that her death "came like a thunderbolt from a clear sky and brought untold sadness to the home of Mr. and Mrs. E.G. Dunn."

Ernest Dunn Jr., an engineer and the Dunns' eldest son, died in 1920 at the age of thirty, during the aftermath of the influenza epidemic that began in 1918. His lengthy obituary ran on the front page of the *Michigan City Evening News* because he had served as county engineer for two years before his death. Prior to that election, he was the city engineer for Michigan City. His wife, Clarriet Wilhelm of Laporte, Indiana, and their five-year-old daughter, Leonora, survived him. His brother, Howard, worked at the time as his assistant, and a second brother, Chester, lived in Gary. Chester, who eventually became president of the First State Bank of Gary and president

Appendix A

of the Gary Board of Works, married Martita Furness, granddaughter of the pioneer family of Furnessville, Indiana. It was this nephew of Alice's who paid for her funeral and signed her death certificate, inadvertently providing an incorrect date of birth—one that persisted even on her gravestone, commissioned decades after her death.

Leonora Dunn died in 1948, at the age of eighty-one, in Michigan City, Indiana.

Nannie

At age eighteen, Nannie Gray married two years after Leonora —in August of 1888—moving to North Dakota with her husband, Herbert W. Piper, a physician. The couple eventually moved to Bondurant, Iowa, near Des Moines, and raised two children. Their eldest child and only son, Herbert Jr., died in 1919 at the age of twenty-nine. He was one of 234 soldiers who died during the influenza epidemic at Camp Pike, the U.S. Army training camp in Arkansas. Although Nannie and Leonora were closer in age, and despite Nannie having left home while Alice was still a child, these two sisters must have remained close: Nannie named her daughter Alice.

This niece, Alice Piper, went on to create a few headlines of her own during the 1930s in Iowa. While working as a nurse, she sued a black physician for failing to follow through on their engagement—and was awarded one dollar for her effort. She eventually married a black man, although not the physician, and became the mother of three stepchildren. The family suffered racist attacks, including cross burnings in the front yard of their house. All of this was reported with headlines nearly as sensational as the ones that created the legend of her aunt—Alice Gray, Diana of the Dunes.

Nannie Piper died in Des Moines, Iowa, in 1948, the same year that her sister, Leonora, died. She was seventy-eight years old.

Hugh

Although the date is unknown, Hugh Gray married an Irish immigrant, Mary A. Flannery. The couple had two children, Mary Faye and Chester. The family lived in Iowa, along with Hugh's brother-in-law, William Flannery. The 1920 census lists Hugh as a farmer. He later divorced.

Hugh died on June 23, 1926, at the age of fifty-four.

Siblings

Harry

Little is known about Harry Gray, other than his marriage to Frances Gray (the wedding date and her maiden name are unknown). According to 1900 census records, the couple lived for a time at 3522 South Hermitage, Chicago, just a few doors down from his mother and siblings, Alice and Chester. Harry and his wife had a boy named Harry.

Chester

Alice's youngest brother, Chester, is the sibling she likely knew best, by virtue of being closer in age and the amount of time they lived together at home. Alice became his guardian after their mother's death. Before World War I, Chester spent seven years in the army; during the war, he worked as an auditor overseas for the Morris Packing Company of Chicago. Following these stints, he settled near his sisters, Alice and Leonora, when he became town clerk of Long Beach, Indiana, in 1921. During the last four years that Alice lived in the dunes, the three siblings were located within about a twenty-mile stretch of beach.

Chester died of a heart ailment on October 7, 1941. He was fifty-seven years old.

Appendix B

Paul Wilson, After Alice

An unidentified white man, believed to have been approximately 55 years old, was found dead on the floor of a lonely desert cabin about a mile north of Freeman Junction Saturday afternoon.
—the Bakersfield Californian, *1941*

The death of Alice did nothing to abate the public's interest in the life of Paul Wilson. For at least six years after her death, newspapers continued to report on his penchant for thievery, his gun-toting ways and his marriage—in a courthouse, this time—to Henrietta Martindale Hyessa.

But it was one of the first articles about Paul, published two months after Alice died, that is most important; it confirmed for the public that Diana's story was indeed of mythical stature and provided the foundation for the popular Diana of the Dunes ghost story. Shared by newspapers from San Francisco, California, to Palm Beach, Florida, the story ran a full page and featured the headline "Haunted by the Spirit of 'Diana of the Dunes.'"[187] Without actually interviewing Paul, the author spun a fanciful tale about his loneliness and immense grief; so intense were these feelings, she wrote, that he suffered vivid hallucinations of his Diana.

At the foot of Mount Tom, where Paul sat and waited for his beloved beneath a rising moon, the soft waves of Lake Michigan provided background music, while an evening breeze brushed across the sand hills. It wasn't long before a ghostly figure pirouetted from a dune ridge down to the water's edge, garbed in a white, billowy veil and moaning sorrowfully as she

Appendix B

drifted along the beach. In Paul's imagination, the writer insisted, the vision was that of Diana. She visited a bereft Paul because he suffered from "the deepest grief a heart may know—the knowledge of failure to keep faith with a loved one who is dead." He mourned at Mount Tom because he could not cremate her and spread her ashes from its great height, as he had promised. What else could his Diana do but haunt the dunes she loved so much?

"And she said that she would come back and haunt the dunes if her wishes were not carried out. So he expects to see her and hear her—and he does!"[188]

Paul's fame quickly fell from that brief, poetic grace and landed squarely in the newspapers' crime beat. In the dozen or so primary stories generated over the next six years, Paul's name is almost always followed by mention of him as the former mate of Diana of the Dunes. He could not escape the legend they had created.

If there was any doubt that his relationship with Alice provided stability for Paul, the newspapers laid it to rest. "After the famous 'Diana' died in February, 1925, her soulmate of an ideal existence in the dunelands was in much trouble. It appears to have been the influence of the mysterious 'Diana' which kept the caveman Wilson within bounds."[189]

He was first arrested by Michigan City police in the spring of 1926 for taking pot shots at a South Shore conductor after he jumped off the train. The conductor said Paul was upset because the train was forced to pass through a stop where he had meant to disembark.[190] Paul, who admitted being on the train but denied using his gun, told police that two men who were arguing near the train had fired the shots, but his story was quickly dismissed. Reminiscent of the diary he and Alice turned over as evidence of their innocence during the murder investigation in 1922, police retrieved a letter Paul had written to the train operator, explaining the incident as he recalled it. In closing his letter, Paul wrote, "I'm too busy just now to be arrested on such affair."[191]

Authorities looking for Paul after the train episode found him "in the hut of an Indian squaw living in the dunes…about four miles west of Michigan City." In fact, she was Henrietta Martindale Hyessa, a white, Wisconsin-born woman who had inherited dunes property.

It seems well-educated women found Paul appealing. Henrietta, an alumna of Smith College, had also done some graduate work at the University of Chicago, 1915–16. While there, she became friends with, and the research assistant of, Jens Jensen, noted landscape architect and Prairie Club member. It was Jensen who inspired her to pursue family property near the Indiana dunes.[192]

Pal Wilson, After Alice

A newspaper story indicated Henrietta had arrived in the region two years earlier to inspect it.[193] A 1922 plat map shows "H.H. Wilson" property in Pine Township, near the town of Pines. In 1924, the local phone directory listed "Mrs. H. Martindale" as owner of Solomon Seal's Lodge.

In the year following the train incident, Paul and Henrietta experienced a whirlwind of change and challenges. Less than a week after Paul's arrest, they were married in the Porter County court clerk's office in Valparaiso, on May 1, 1926. At the time, he was still out on a $2,000 bond paid in part with money from Henrietta's mortgaged property.[194]

Less than ten months later, on March 14, 1927, Henrietta asked Porter County authorities to arrest Paul and place him under a peace bond because he meant to harm himself and had also threatened her life and that of "her little daughter"—seven-year-old Bonno, a child born to Henrietta during an affair with Dr. Charles Eastman.[195]

In seeking his arrest, Paul's wife told Michigan City police that her husband became angry when she could not "meet his demands for money." During several days of hiding, Paul was sought by both Porter and LaPorte County authorities. They caught up with him at the "clinic sanitarium in Michigan City," where he went to see his wife who was a patient (the reason is unknown). He was carrying a .38-caliber revolver.[196]

Earlier that day—at Henrietta's request—Porter County Superior Court judge H.L. Crumpacker withdrew the bond that she had posted for Paul's release while he awaited arraignment on the shooting charge.[197] Paul could not raise additional bail and was held at the Michigan City jail after being arrested at the hospital on a charge of carrying a concealed weapon.

It was reported that he consumed match heads—an entire box of them—in an unsuccessful suicide attempt during that first night in jail.[198]

A week later, on March 21, 1927, Paul was sentenced to one year in jail.

Less than three years afterward, on November 17, 1930, he was back in Judge Crumpacker's court on burglary charges involving "seven minor jobs," including theft from the Pine Township Farm Bureau.[199] Henrietta again posted bond, and he was released.[200]

By this time, Henrietta and Paul's family had grown with the birth of two more children. No doubt at Paul's insistence, they named their first daughter, born in 1928, Diana. The couple's second daughter, Henrietta, was born in 1929.

Just before they would have celebrated the new year in 1930, the Wilsons were devastated by the loss of their house in an unexplained fire: "The home of Mr. and Mrs. Paul Wilson on Dunes highway near Furnessville was totally destroyed by fire of unknown origin early Monday night. No one was home

Appendix B

at the time and when neighbors arrived the fire had gained such headway that nothing was saved."[201]

If Paul possessed any remaining manuscripts or diaries once belonging to Alice—at one point after her death he had tried to sell them—they were likely lost in the fire.

One week after his family's home was destroyed, and while he was still free on bail, Paul was arrested again. This time, the charge was reckless driving[202] in regard to an automobile collision that sent three men who were "badly battered" to a Michigan City hospital. The accident occurred at West Tremont on the Dunes Highway. A news story reported that Paul was injured, but the state police brought him to the Porter County jail anyway. There was no mention of the extent of his injury.

Then, on February 5, 1931, Paul was sentenced on the burglary charges and sent to Indiana State Prison for a term of one to five years. Not surprisingly, the court took his criminal record into consideration:

> *Wilson, who is thirty-eight years old but appears somewhat older due to his graying hair, told the court of his sick wife and three children and begged leniency on their account. But Judge Crumpacker, after a lengthy review of Wilson's past criminal record and general disrespect for the law, refused to accept his plea and imposed sentence.*[203]

For his prison file,[204] Paul provided some interesting, if not wholly truthful, personal information. His aversion to using the name Eisenblatter was evident, since he identified his father as Otto "Wilson" and his mother as Caroline "Westman," her maiden name. He indicated his parents were living together—although his mother was long deceased—and that their financial position was "poor." He claimed that he had no brothers or sisters. Paul also told authorities that he left home at age sixteen and that his education extended to the seventh grade. In response to a checklist of questions, he answered that he smoked cigarettes and drank "moderately."

Although he was given two brief temporary paroles, Paul spent nearly two years in jail; he was released on January 26, 1933.

At some time and for reasons unknown, the Wilsons moved to California. The next time Paul Wilson's name was published in a newspaper story, it was to report his death—and the story began with a familiar theme: "An unidentified white man, believed to have been approximately 55 years old, was found dead on the floor of a lonely desert cabin about a mile north of Freeman Junction Saturday afternoon."[205]

Pal Wilson, After Alice

The man was identified the next day as Paul G. Wilson of Freeman Junction, California.[206] On the death certificate, Paul is listed as a "transient." He died of a ruptured aortic aneurysm on "about" October 25, 1941. Although Henrietta is named as Paul's wife, the record also indicates he was divorced.

There was little to know for certain about Paul's life; the same held true regarding his death.

The funeral of "Paul Wilson" was held in Bakersfield, California. An obituary in the *Michigan City News Dispatch* announced the death of "Paul George Eisenblatter." He was survived by two children, and by two sisters, two brothers—and his wife.

Appendix C

Alice's Diary—Excerpts

Acquiring "The Diary of Diana of the Dunes" was no doubt a journalistic coup for the *Chicago Herald and Examiner*. On June 1, 1918, a large, three-column advertisement was printed to promote publication of the diary in the next day's newspaper. The ad copy synthesized the most popular details of Alice's public persona: she was smart, living in the wilderness and suffering from lost love. What readers would discover, the newspaper implied, was that Alice was also a gifted writer:

> *Written in the wilderness by a girl who went there to die but remained to live the wild and primitive life of a modern Eve. She was a student at the University of Chicago. She loved a brilliant man who mocked at marriage. Hers is the strangest love tale ever written. This, with her letters, which are the literary sensation of the day, will appear exclusively in tomorrow's big Super-Sunday* Herald and Examiner.

By this time, Alice had lived for three years in Driftwood. After her dunes life was revealed in the summer of 1916, she became a favorite story in the press, but that initial burst of publicity eventually waned. She was back in the news in the spring of 1917, when she was lauded for her Fullerton Hall speech advocating preservation of the dunes. But for more than a year, until the diary was published, the newspapers had nearly forgotten her. For a woman who said time and again that she sought solitude, it seems surprising that Alice turned a portion of her diary—from November through February

Appendix C

of 1915, her first year in the dunes—over to the Chicago newspaper. Surely, she worried that such publicity would re-ignite the public's interest in her sojourn and spark more exaggerated reporting. Or did she seek the attention?

Perhaps, Alice sought to publish the diary as a way to renounce her relationship with "L." During the late winter of 1918, when Alice lived temporarily with the Johnson family, she received a personal letter. Her response—"And I thought he believed in free love!"—might indicate that the author of the letter had revealed something upsetting to Alice about "L." Was he getting married, or had he already? If so, publishing letters that she wrote to him, but never mailed, might provide some necessary closure for her. The newspaper, in introducing the first diary installment, noted this about the mysterious "L.": "Should he read this he may know her letters for the first time."

Alice had met Paul at least by the winter of 1917, just before he was incarcerated for six months on charges of stealing from neighbors. He had moved into her shack by the time of the diary revelations. It might not have seemed so daring, then, to finally let go of her Chicago relationships.

On the more practical side, it seems certain that Alice was paid for her diary. If "L." was no longer of consequence, why not provide the intimate details? It may well have been a matter of survival.

The "Diary of Diana of the Dunes" was published, in excerpts selected by *Chicago Herald and Examiner* editors, from June 2, 1918, through Thursday, June 6, 1918. (Although the newspaper refers to a Wednesday, June 5, edition, that installment could not be found.)

Chicago Herald and Examiner

Sunday, June 2, 1918

"The Diary of Diana of the Dunes: Her Love Letters That Were Never Mailed"

A few miles east of Chicago lies the sand dunes of Indiana, a wilderness of primitive beauty that has moved lovers of nature to petition the government to set it off as a national park.

Glistening torpedo sand, glacier strewn and wind blown, forms valleys and mountains topped by fir and pine trees. Orchids grow there in brilliant variety. The beauty of shore,

Alice's Diary—Excerpts

lake and sky have so charmed artists that at present we have a special exhibit of Dune paintings and photographs at the Art Institute.

The spirit of this domain is a wild girl, Diana of the Dunes they call her. Fishermen, scurrying to shore before squalls, have been startled to see her breasting the waves far out in the lake. Hunters have chased and been chased by her. Reporters have often penetrated to her driftwood hut in the wilderness, but learned little more than that her name is Alice Gray and she was one of the most brilliant students turned out by University of Chicago.

It is the privilege of the Herald and Examiner *to solve the mystery of Alice Gray and to present extracts from her diary. Those who have read it pronounce it a literary sensation.*

She had been engaged by a man to assist in the preparation of a book. It dealt with the problems of sex and society. The man, older than she and more worldly, made love to her and she thought of marriage. But his theories of life disillusioned her. With vague ideas of going off alone to die, she bought a ticket to get as far away from Chicago as her money would allow. She alighted in the dunes.

One night, alone, under a primitive hut, and she awoke to the beauty of the dune district. She found that she wanted to live. And she has lived there ever since, setting down her thoughts in a diary and writing very human love letters to the man—letters that never were mailed. Should he read this he may know her letters for the first time. When she went she was weak and sick, hating the world. Now she thinks nothing of a twenty-mile walk at daybreak or a swim that would frighten most men. The diary:

Beach Near Dune Park

Nov 7, 1915

Nov 10—Wednesday

I have been out just a week this morning.

To-day is more like July than November. I've taken off my arctic apparel and hung it up in the wind to dry.

There were two rather large camping parties near me Sunday. I sat around and climbed near-by slopes and kept an eye on my possessions. But it was quite needless.

What is it, I wonder, about photography that is so eminently respectable? The two campers had a camera with a high stand, and at once my fears of them subsided.

The men off by themselves were heard to mention "mother earth" and "acquiescent," and of course were thereby beyond suspicion as to blanket filching.

Appendix C

They seemed to have a good effect on me—a calming, suspicious-allaying, confidence-bringing effect.

The larger party left with a call to "Mr. Hawker" to "hurry up or he would miss the sunset." I always smile at such a remark; sentimental, I say. And yet—last night I exclaimed, "oh, my God!" as I saw the new moon above the bands of yellow in a zone of clear greenish light. Wonderful, wonderful, wonderful!

Now, on this cloudy afternoon, as I sit and look over the milky green on the lake between the trees defined at the horizon with something darker than I should not know whether to call greenish or bluish or reddish. I feel sometimes as if I could faint with the rapture of it.

Back of this hill there is a wonderful sweep of sand up to the heights—a great wash, really the great white way. From the top of that hill is a wide prospect—brown hills in the distance, over the tops of oak woods, and back to the lake between the dunes. The road I take to the farms and the railroads lies that way, sharp down into the oak forest in the valley. How exquisite the bare sand hills stand out coming back, especially in the subdued light at sunset.

Thursday morning with many anxious thoughts as to my blankets, piled under the cedar saplings by the roadside, I started off over the sand wash along the road through the bottom.

It really was not far to a few cottages, and then the railroad and the highway, and more or less farmlike places. But I had a hard time getting anything; no one had eggs or milk or bread to sell. Finally I got some milk and bread, and then met the traveling groceryman and got supplies—eggs, cheese, bacon, bread, butter; more than I could carry, so that I had to hurry back for a second loaf of bread.

Pain! And the Keen Edge for Living!

And when I got home—that comes natural! back-heated in my heavy clothes, I climbed the great white way again to see the sunset. Then I remembered that it had rained a little the night before, and my blankets were a little damp. So I built a fire in the iron box I had found ready at hand, which makes cooking so unexpectedly convenient, and spread out my possessions on the ground around it. I sat in this state of joy, thinking very much of L. because I had been using what Miss H. called his word so much—"wonderful"—and thinking that I was what he had called me —"Alice sit by the fire," whatever that was supposed to mean. Feeling very happy and domestic and much pleased with myself and the world, my world, large and small—when, the fire dying down, and my towels being not quite dry, I moved the iron firebox

Alice's Diary—Excerpts

with the idea that the sand under it would be the best means of finishing the drying, and deliberately put my hand—my right hand—caressingly on the sand to see if it was warm enough to do the towel much good, I suppose.

My God—how it hurt!

The shame of having done such a fool thing was hardly second to the pain of the burn.

At first I thought I would never tell the story. Then I reflected that human perfection of any hurt is so rare that none of it ought to be hidden under a bushel, even perfection in folly.

I contemplated walking the beach all night but soon found it very cold. Then I went lamely to make my bed.

I was thinking how much I wished I were not such a coward about physical pain. I found myself admiring Mrs. M. and N.R. and in general the women I rather despise as Philistines, who nevertheless are morally far superior to me in that respect at any rate. I was in imagination talking to L and saying that I knew I was physically too much of a coward to have children. I found myself even admiring his mother for her bravery in endurance.

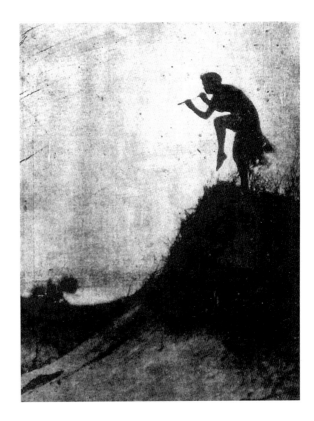

This photograph accompanied publication of Alice Gray's diary in the *Chicago Herald and Examiner* on June 2, 1918. It was credited to photographer Robert Sansone and was part of Chicago Camera Club exhibit at the Art Institute in Chicago.

Appendix C

As to the hand, it hurt more or less all night, I think, but didn't trouble me much. I had been afraid it might fall off, but I guess it was really nothing serious. At the worst, I reflected, I should be inclined to agree with God that one hand is enough for a perfect fool.

Yesterday, I gathered a few pine boughs for my bed, and found it a great improvement. I am afraid the oil cloth and the blankets were hardly enough over the cold sand. It seemed almost sacrilege to break the trees. I wonder if they grow up on top, and don't mind the loss of the boughs I can reach.

I seem to run to negatives in thinking of the pine (or fir). It is the opposite of the pettily human—the anxious, the care sodden, the duty frazzled.

Duty is calming and unifying and life-giving and restful, but there is an imitation, very common among the descendants of the Puritans, which is much the reverse.

Tuesday, Nov. 16

Toward Sunset

Dear L.—I wonder why we got stricken dumb so often. Why didn't you talk to me, as you said you wanted to, about your plans for the book? And so very often when I seemed to want affection, what I had wanted—or thought I wanted—was to get our notions cleared up.

I wrote you a letter or two before I left. One of them, as I remember, was rather enlightening. It said that my disquietude was because I had sinned, in losing the disinterestedness which is my true attribute.

I think I have regained it out here.

I'm getting fond of your word, as L.H. calls it. Those were very kind and wise words you wrote me: "The world is very big and wonderful, and you must be very sweet and patient or it will be unkind to you." Now, I think, though; you really meant, "Be very sweet and patient with what seems its unkindness, and you will find it very kind."

Cabbage and Sunsets to Make a Poem

Wednesday, November 17

The above might have been entitled "While the Cabbage Cooks and the Sun Sets." I stopped to run up the hill above my bower to see how the weather promised. On coming back I ate the cabbage—which, with plenty of bacon

Alice's Diary—Excerpts

grease, was delicious—and then had to make haste to get ready for bed as the clouds had that murky yellow cast which I thought meant snow.

This open air cookery reminds me of Lamb's young Chinaman; it sometimes seems as if I were burning down a wood to cook an egg. Not that I build a big fire; I remembered L.'s remark of the Indian—the Indian builds a little fire and keeps warm; the white man builds a big fire and freezes. Moreover, my stove being about 12x12x20 hardly tempts to excessive size.

My stores are now reduced to three eggs, half a slice of bread, a little oatmeal, coffee and salt, a bacon rind and some grease, a cabbage and a very few apples and radishes. Money, eighty-two cents. I hope Dr. A. sent me a remittance! And that is a pre-breakfast inventory.

Now after breakfast—oatmeal in lots of bacon grease, two fried eggs and half a slice of bread, two apples, and the remains of last night's supper's cabbage, and a quart of coffee, evaporated down to one small glass—and a trip for water, to return to L. and the meaning of life—or shall I go for a possible letter?

I notice that when I am in a happy and satisfied mood I tend to think very well of L., but when I feel outcast and rather abused—as last night in the wind and rain—I scorn him utterly—both for business and personal relations.

Dear L.—Are you ever suspicious of me and irritated with me? Or have you really, to your own satisfaction, "my number"? Sometimes I think you don't understand me at all—that you misinterpret me wretchedly, meanly, vilely, insultingly, and then again I think perhaps you see me as I am, in actual feebleness and possible strength, as it were well if I should see myself. And sometimes I admire you and love you, and again I despise you and—not hate you—I have hated you, I think, only for one moment, waking up for one morning just before I left Chicago and seeing you, not with vine leaves in your hair, but in a foolish paper cap, "grinning"—but think how could I ever waste a thought on you.

You said people never understood what you mean—that I never should. Then, perhaps, it is not, as I have sometimes thought of myself, that I am stupid and dull, or at least slow and uncertain, in sizing people up, that makes me uncertain as to you.

It seemed to me, however, that your real feeling was—whether you were struggling with conflicting feelings, or held back from its expression by a sort of pity for me, a feeling that I called on you for aid which you were loathe to refuse, although you felt either that it would be too costly to you, or that in reality I was hopeless—or else made uncertain in its expression by mere

Appendix C

politeness; but it seemed to me that your real feeling was that, as to having any relations with me, the game was not worth the candle; that you were trying to detach yourself from me, to "shake me," as the expressive slang has it.

And He Said I Was a Nice Girl, But—

I felt it that night when we had a sandwich at the Greek's, and you said, "You really are a nice girl: I really like to have you around—but—"
 But—what?
 Shall I guess?
 You know, you are a fearful waste of time. Not a waster of time—I like to kill time myself, sometimes, often, a lot of it. I believe in it. But you are a waste of time: futile, vain as a driving wheel without an attachment. You think you are something—that you are much, but you are nothing, just because you think so much of yourself. To be brief, you are not yourself, as a human being should be, which would demand relationships—ties—but to yourself enough, and so a mere troll, a vain imagination, nothingness-in-itself. And I, if I had much more to do with you—might find it contagious. In any case, you are unprofitable to me, who have a work which calls me and a place in the world—of which I am as proud in my way as any grandee of them all.

Tuesday, November 30

Sunday night going to bed in a windstorm was quite a wonderful experience, as L. would say. I felt perfectly safe and happy, and a little excited. I intoned the Lord's Prayer over and over—and was really in the spirit of prayer and worship, wanting nothing, fearing nothing, asking nothing, but to be shown my duty and given the grace to do it filled with the beauty of the storm and with the praise and worship of God. I had thought to say to Mr. N. in a joking way that I found fasting easier than prayer, but less easy than eating; praying is a gift which is not taken by violence or by desire for it. Yet how beautiful, how satisfying it is when it comes, prayer.
 L. says I have not been in the right soil. He said I should be popular to his set. Popular? Ye gods! I always think of myself as a supreme bore to the people I know. Emerson says if you are popular in your set, it is a bad sign, but if people look at you with strange looks of regret and half dislike you are probably different.

Alice's Diary—Excerpts

Generally—especially when I write, or walk, or sing, or read, or recite my favorite poems—I am very, very happy and contented with my lot and my course. Then once in a while I wonder if I am childish, futile, foolish, a "skulker" as some one [*sic*] called Thoreau—a nonentity, a shirker and deserter and coward and egoist. Yesterday was one of the days of such doubt of myself.

The highest bravery in the world is loyalty to one's trust. It may be simply withstanding the world, refusing to stoop to court, or to compromise, letting the world and its glory pass by without a regret or a thought, willing to be thought nothing, but in reality, in one's self possessing one's own desire.

Yesterday I longed for society—the companionship of some big, clear-eyed, single-hearted, frank soul, who would talk to me as L. says, about life and love, about God, freedom, immortality.

Is L. such a person? N.J. says L. is not simple and therefore not great. I wonder if she does not [unreadable] him from the outside—though she likes him—and if, perhaps, I was not speaking the truth when I said lightly to that foolish telephone talk with "Cousta Helen" in response to her question, "Do you believe anything he says?": "Of course; hearing him is like listening to my own soul."

I wonder if we might be friends, if he would like me as a friend, or if my "stimulating" effect, as he call it, spoils me for friendship, or if he finds in me no satisfaction, no promise, no interest, or attraction in that way. Perhaps I should be disappointed in him; as he said in a letter to another person: After all, our friends, like our gods, are our own creation; we it is who endow them with the qualities we love and which satisfy us.

Yes, but the test of their truth and reality, after all is just their power to be endowed with those qualities—to let us endow them and feel the endowment; to throw back to us the balls we throw against them, the rays of heat or light we sent out.

That is the only difference between a wall of solid masonry and a bank of fog for the purpose of handball, and that is the difference between a friend and a disappointing acquaintance, between the god of one's own soul and another man's god.

I wonder if L. really wants me to think about him, and love him as I might love, should love if I loved at all—or if he would rather say "ships that pass in the night" and let us forget one another.

The love I have always idealized primarily is a platonic love—my thoughts of sexual love have been of a lower power, and likely to end in—what shall I say?

And is not this exactly what L. felt, only he used the terms 'love' and 'stimulation and desire and happiness'?

I wonder if he dreaded, or at least felt the danger, the possibility, not only of too much "coaxing" but of too much kindness and sympathy—or if I am endowing a rather elemental creature with refinement of honor of which he never dreamed?

Strong in Grammar, But His Ideas—

He said in writing his book, he wanted to avoid "ought" or "should" and all such terms. Yet he said to me, after the parting, the night of passion in the form of regret, and the note in the morning—"I felt that I ought not to have left you in that way, when I had been thinking about you as much as I had been."

Yes, that is what interested me in him, I think, as it always has in novels and poems and their authors and all men in general—what is his philosophy, his ethics, his criterion of right and wrong, his standards of *honor*? What does he admire, what despise, what long for in the moral world?

I think L. and I might have had a great friendship—if—

Just think, dear. I have never had a friend, except my mother, who died thirteen years ago.

Thursday, Dec. 2

Yesterday, I walked south through the woods and struck, not as I expected, the old Chicago road, but the road which I first followed home as a variant from the Chicago road, which comes out on the beach at either the first or second sweep to the west—I am not sure which.

Miss E. was not in, but I took the [liberty] of looking in the mail box and found there the letter I was looking for—with three dollars, and a general… [text is unclear] "fatherly" tone.

I stopped in cheerily on my way back to see Mrs. B. Combing her hair, she referred to her looks, and that reminded me to look in the glass.

What a sight! I looked like a delirious Indian. Nose red from a little cold and much wiping—eyes pale and staring in the general smoky red, teeth pearly by contrast, and, oh, what a forlorn, unwashed, gaunt face!

This morning I washed in hot water and plenty of soap—I had only a rub off before since the day by the fire in the wigwam—and looked civilized except—as the glass revealed—for a grimy underchin and neck.

Alice's Diary—Excerpts

I wonder if this life is really so good for me as I thought. 'As good as a sea voyage," I said in my letter to Dr. A.

Friday, Dec. 3

Dr. A. said in his letter—I said in [unclear] I seldom make such frank statements about my circumstances, they generally do no good and are likely to be misunderstood—that I had not been too frank and only a "false friend" could find fault with such a letter; it was a relief to confide in some one, if one got the right person—as he was!
To be continued in tomorrow's Herald and Examiner.

CHICAGO HERALD AND EXAMINER

MONDAY, JUNE 3, 1918

"DIANA OF THE DUNES DISSECTS SOUL IN DIARY: LETTERS TO 'L' REVEAL ROMANTIC SIDE IN NATURE OF THE MYSTERIOUS GIRL LIVING IN THE WILDS"

Tells of Preparing New Book

In the first installment of the diary of Alice Gray, the "mysterious nymph" of the sand dunes, she told of her first days at the wild lake shore after her flight from life in Chicago. Today the Herald and Examiner *gives that portion of her remarkable diary dealing with her final work on a certain doctor's book and gives several of her letters to "L." Since, to change a quotation, "the most interesting study for man is woman," you will find these letters interesting. And, living alone amid dunes, as her letters tell, the University of Chicago student found so many primitive things to interest her that she fell in love with life again. Her diary, continued from yesterday, reads:*

Well, it seems the good old doctor does misunderstand me a little, though I guess it won't do any harm. It isn't sympathy or relief of my feelings that I want; or at least that I was looking for from him; but as I said I hate to press him for money, and have felt all along rather apologetic to him for making

Appendix C

him wait so long; and so I wanted him to know why I was in such a state of mind, and just how I needed money now, so that he will not keep me waiting at a ruinous cost to me.

One day—it was well along in October I think, when the work was nearly done—it seemed I just could not keep my word and finish the work. I called him up and told him I was unable to go any further. He said very meekly—if I remember the words—"When do you think you can work again?" The impression was strangely deep of patience—of something old and patient—especially old and infinitely patient. I had not the heart to throw up the work and disappoint such patience.

Shrinks From His Kiss

I do not mean that I thought of Dr. A. himself as old; he has a sort of boyish buoyancy and hope, despite his sixty-seven years.

That might sound to a stranger as if I idealized the doctor. Not in the least. Personally I rather dislike him, or at least shrink from him, as he would bore me to death.

While I'm on the doctor—the last scene. He was proud of the book "and of me." I was a good girl—he was going to kiss me good-by. (Business of doing so.) Then, at the door—oh, by the way, how much did he owe me?—I hadn't meant to charge him much, because of the delay. (I had meant to leave all above the original $40 to him.) But how much? Say—Well, would $75 be too much? He gasped a little, but said quickly "Well, I won't jew you down. But you won't get it all this month. Don't tell my sister—I'm going to kiss you again."

I was glad the rest of my transactions were to be with the printers.

But it did at least reveal to me the distance between one person and another when it comes to kissing. There is indeed a certain temperamental suitability between L. and me.

Various and strange indeed are the sources of knowledge in this world.

Dear L.:

This is a business letter!

Is your book written, writing or to be written?

I am having a good, restful and recreative time, living outdoors on the dunes. I shall stay here [sic] until the weather drives me home. I came Oct. 31.

I finally got Dr. A.'s book out for him—proofreading and all. He was very patient in the process and grateful after it. Unless his hopes prove vain, he will send me money enough to live on while here and probably to get started on again in Chicago.

Alice's Diary—Excerpts

As to working with you, I'm not counting on it, and—having got back to my normal state of poise and philosophy—shall take whatever outcome eventualizes as the best of all possible outcomes.

But you said once you didn't see how I could be—as I said I was—interested in the book. And I wanted to say how that was.

I am very much interested—and always have been—in sex problems, though primarily in somewhat different phases of them, I suppose, from those that especially interest you. And so I really value the opportunity to get acquainted with the literature, and still more with the information you have personally.

Have you paid much attention to what I call diffused sex? That is, sex feeling that is so transformed and disguised that it is not recognized sex feeling at all. I think, for instance, that Mrs. Humphrey Ward—and oodles of dames who let rooms are full of diffused masochism.

That, together with the possibility of working in good light and air—makes me feel that I should prefer working with you at a few dollars a week to a job with four or five times as much salary in an ordinary office.

But I dare say I am a thing of the past in your busy days. I have though—on suitable occasions—thought of you. For instance, the first two or three weeks I went in bathing every day, and not daring to go in deep alone, thought how nice it would be if you were here to take me far out into the lake.

There have been many other times too—L. Times when I would say—What—and is it really you again? quoth she.

I again—why, what did you expect? quoth he.

Finds Few Worth While.

Toward Sunset

Dear L.: There are a few in this world who will say truly what they think, and still fewer perhaps what mental processes—observatory or expressive—are accurate enough to make their opinions of any value. I do have considerable respect for your critical qualities—your criticism of L.S.'s article confirmed it—you see when you really give me the benefit of them. Which is not so often as it might be. Does "stimulation" as you say (I think I have asked this better in an unsent letter) spoil a friendship for you? If so, I hope I have ceased to exert it for you.

From this sheltered nook the sunset is just an almost white brilliant in the west, pinkish in the east. I have just climbed the slope in the east. There the

Appendix C

lake is seen in a wide sweep and the horizon is banked with blue clouds, with an intense pink above them in the east to northeast. The sunset is not brilliant.

I have been—for me—just a little depressed the last few days—ever since I came up here, perhaps; but think it has been due entirely to physical causes—food and thin clothing. How glorious this outdoor life is—how good life feels and tastes and smells down close to the great elemental things; this blazing fire, with the white brilliance in the west, just one star (Venus or Jupiter?) high up in the southeast, the dull white snow patches in the hollow and on the southern slopes, and the snow-flecks brown of the western slope, and the light gone for writing and the time come for supper.

Meets Beach Hermit.

Saturday, Dec. 4

(Addendum to next to last installment)

Dear L.:

Just don't imagine that I spend my days and nights up here going in bathing (I did go in yesterday, but I'd like to see myself going in just now with the frost still in the air), climbing hills to gaze at views and wiggling my toes before the fire. Far from it.

I shall have great tales to tell when I get home, if I care to tell them, of the man I met when I went for water at the big pump a mile from here—quite in the style of Isaac and Rebecca; of the hermit down the beach, with his warm cottage—which he early extended me a genial invitation for inclement nights and his cheery little cupboard with its smoked herring, which he has caught and smoked himself—and fine wine and whisky; the man who came from the train with me the day I arrived—the day that was crowded with thoughts of ending it all—and the man I met on the sands last Saturday: the six men who came down to fish Thanksgiving night, and invite me to the fish supper on the beach—(I liked them, especially the witty one, who, himself being Irish, "just hates Swedes!").

The world is so full of such WONDERFUL men.

How COULDN'T a woman be happy, sweet Len?

This represents a delicately subdued but prolonged smacking of the lips.

Alice's Diary—Excerpts

Letter Spoils Mood Toward Sunset

I actually copied the business letter to L. with the above nonsense this morning and took it to town to mail with a note to Dr. A. The postman had gone, so I came back with the letters and two quarts of milk and went to my old place. I built a fire, had much bread and cheese and a little coffee, and the day is nearly gone.

There was a letter for me from Dr. A., which, hastily read, spoiled my mood. Yet as I read it again there was no reason why it should. He assures me he has understood my case from the first—my abilities call for a better position. That statement revived the feeling which had made me almost loathe myself while I was doing the work: that I should be reduced, stooping to such means of earning money—what a prostitution of my powers! Not that the doctor is consciously dishonorable, or perhaps really worse than the most eminent in his line: but I don't believe in him intellectually.

I hope Dr. A.'s remark, that his last letter had answered all three of mine and that this was to be on a different subject, meant that he would send me two or three dollars at least again next week. But I shall send him the reminding note and trust that I shall be fed. It wouldn't take much fasting to unfit me for this life I feel sure, delightful as it is under the right conditions.

(Another installment of the diary will be printed in an early issue of the Herald and Examiner*).*

CHICAGO HERALD AND EXAMINER

TUESDAY, JUNE 4, 1918

"DIANA OF THE DUNES SAYS 'L' BROUGHT HER SUNSHINE"

Alice Gray, the University of Chicago girl who fled from routine to live "the free life," became the "mysterious nymph" of the Indiana wilds along the southern shore of Lake Michigan.

In the first installment from her diary in the Herald and Examiner *she told of the many primitive things she found to interest her.*

Appendix C

In the second installment she dissected the soul of a woman as it was given to her to see it and disclosed the romantic side of nature as shown in the wilds.

Her diary, which she regards as a substitute for society, continued from yesterday, reads:

Dear L.: You said I hadn't been in the right soil. I'm inclined to think it would be more accurate to say I haven't been in any soil at all for a long, long time. Except for books—and that, of course, is a noble exception—and they almost exclusively from a tolerably distant past—I feel as if I had nothing valuable and sustaining coming to me from without. I have lived from within and drawn all my strength and power from myself. My environment has been the source only of irritation and perhaps a little poison.

Until you came! Yes, you gave me a touch of sunshine, and society, and interest, and kindly humanity.

To be sure, I have often had the promise of those things—which generally proved illusory and disappointing and even harmful—like drinking sea water for thirst. And so I doubted and mistrusted you, too, and was ready to see selfishness and appellation—not economic. I hadn't thought of that, but emotion.

Well, and did you decide that I was a weariness and a nothingness and a striving after wind—that I had nothing for you, or so little that it wasn't worth getting out? Would friendship for me be too costly to you? Then, of course, I shouldn't want it and it wouldn't really be friendship.

I often think we might mean a great deal to each other, that we can understand each other and value each other, and help each other in strength and cheer, as few persons can perhaps one another, and almost none either of us. [*sic*]

I felt—though I never said it to you—when I was so discontented with my environment, that yours was not right either. Martha or Uncle Dave or some one else always came along just when you were ready for work. My idea of a little flat, with the solitude and isolation and freedom I prize so highly for myself, meant also the right place for you to work. As John Morley says of Mme. du Chatelet, the "divine Emily" of Voltaire, she poured a cloud about her hero, like an Homeric goddess; and Morley thought she could not have done a better thing for Voltaire—who, by the way, was much annoyed by the police of his day. Although it was from his friends, not his foes, that the divine Emily was wont to snatch him. Every house has its atmosphere, which favors either work or idleness, says Morley; and the house of Mme. du Chatelet had an atmosphere of hard work. She, by the way, the translator of Newton—in a day when that meant high attainments—died of a venereal

Alice's Diary—Excerpts

disease caught from a stray lover—a certain duke, I believe, and Morley says the sexual irregularities of that circle, the atmosphere of whose house was hard work, were due, not to their inclinations, but to the belief that virginity was Christian, and hence despicable, if not damnable. The same conviction produced "La Pucelle," with its—to us—amazing misunderstandings of Joan of Arc.

Don't you think a house with an atmosphere of work would be good for both of us? For we both can work, I know, and I haven't worked for a long, long time—really never as I could and as would be good for me. And you? In spurts on indifferent things?

But perhaps your work is really what you have been doing—probably it is social, stirring, mixing with people. And the concentrated, abstracted, solitary activity which is my real atmosphere—without which I shall never really live at all—might not suit you in the least.

No, I have not lived. Is that why, at nearly the same age, I FEEL so young, and you so old? I think of myself as on the threshold, just starting in life—to the great amusement, I know, of a certain type of person. But that was Plato's idea of thirty—the end of "school," the leisurely preparatory period, and the beginning of active life.

I have had the feeling all along, as Wordsworth says of his Cambridge days—the feeling "that I was not for that place nor for that hour."

And I have let myself be exploited frightfully—from a too delicate sense of honor and responsibility for the environment I was in. For the quality of whatever work I do, my conscience is an inexorable taskmaster.

Sunday, Dec. 5

I am beginning to think a little—or rather look at the subject a little; it can hardly be called thinking—as to what I shall do when I get back. I really have no plans, no projects, and no hopes, as well as no expectations. I don't know whether L. means to go on with his book or wants me to help him if he does, or whether it would be a good thing for me to do that work. I am interested in the subject and would like to get familiar with the literature and with his own information, theories, ideals and ethics on the subjects. I haven't fully made up my mind as to him; I do not regard him as negligible or inferior, a sort of chimpanzee, as I do many people. I believe I should like to try it.

So perhaps after all my hope is that L. and I shall get to work together after Christmas and that I shall work from that into some independent

Appendix C

writing. He might get me started on some live subject where I could produce something—as M.L. said I should have been doing long ago—for which there is a demand.

Wednesday, Dec. 8

Hurrah for the good old doctor! Two dollars! Also a dear good letter from L.—and he wanted me—was looking for me! I don't know how long the job would have lasted, but doubtless I was better off here.

He hopes in his letter that "life may be kind to me."

I don't believe the world is, or will be, very kind to me—though I don't wish to underestimate what it has given me. And I should really like to know whether I should call L. unkind or the reverse. I can't make up my mind as to that. But God is kind—I feel that. What bitter experiences and unkind treatment are changed into blessed and precious things. For instance, if I had not been desperate I should not have thought of coming up here; and how wonderful, how unspeakably healing and sanctifying it has been living in all this beauty and this keenly vital air and in the blessed solitude.

And now forever a sadder and a wiser woman—let me forget that acridly chemical atmosphere—even corrosive atmosphere that I knew—now that I am living in the world that belongs to me and to which I belong.

As I sat by the fire last night I thought how wonderful it is, this beauty, so simple, so elemental, yet so inexhaustible and so varied—no two fires alike, any more than two leaves. And then I thought how I am reproved doubtless by most of the people who think of me at all—which isn't many—as wasting time here; and, then, how necessary to the spirit are these hours of quiet and unemployment, of basking in some "loved presence." The critic who justified the "almost intolerably" slow movement of one of Goethe's novels as corresponding to the temporal lengthiness of life itself hit a great truth: if we find it tedious it is because—as the moralists say—we are wrong; or else we are in the wrong position.

But I hold that there should be great quantities, vast reaches of this slowness in life, and if we work efficiently and with our might when we do work, and prune off as we should the foolish futilities in which most of us are prone to branch out, we shall all be able to afford the time for this depth-giving solitude and leisure.

How hysteria and all unwholesomeness flee away in this life! The great, calm, unconcerned dunes, the tonic, icy air, or the glad glaze playing about the gargoyle forms of the smooth old wood—declare that "all is beauty."

Alice's Diary—Excerpts

[Another installment of the diary will be printed in the early issue of the Herald and Examiner.*]*

Chicago Herald and Examiner

Thursday, June 6, 1918

"Diana of Dunes Loses Fear of Men: Continued from Yesterday"

Spends 3 Days in Bed.

Monday, Feb. 14

Two weeks since I have written! I don't know what I have done except bring up wood and go to town a few times and spend some cheerful evenings and a few chilly ones by the stove here.

Last week I spent three full days in bed—Sunday, Tuesday and Thursday—scarcely turning over for thirty-six hours or so. I was perfectly well, but thought the rest would do me good and followed my instinct.

Friday I walked to Oak Hill and while waiting for Mrs. Larson to come home with my groceries I had the first good look I have had of myself in some time. To tell the truth, I was rather shocked. My eyes seemed to have a rather wild, strained look as if the life I was leading were very wearing on me. I said to myself that I would be afraid if I met myself alone at the crossroad in the moonlight. However, I was not so bad with my hat and coat on.

Opposite of Gentleman.

Toward Sunset.

I have been trying to think of the opposite of gentleman in the highest spiritual sense of that word, as ineffectually as I have yet sought the opposite of "earnest and reliable." Yet there seems to me there is such a word, not

quite "vulgar, low or mean," not quite so definite as "churl." I have wondered if that word when found would not apply to L. I wonder if he is not, intellectually, a bit of a charlatan, with his pouncings upon foreheads which he refuses to elucidate and his certainties about the relations of appetite for food to sexual life. I know he lets his own desires bias him more than he realizes in his interpretation of other people's needs: common, perhaps, that trait.

The trouble with me the last few years is that I haven't been doing my own work; I have let my strength go into the perplexity as to what I ought to do. The periods when I turned from that barren perplexity as to what I ought to do, when I felt I must do something to earn my living, and yet couldn't think of what to do. The periods when I turned from that barren perplexity to read Balzac and Flaubert now seem oases in the desert. If I had had faith and gone on energetically with either mathematics, or logic, or ethics, or literature, or politics, or any combination of two or more of the five, or anything else under the sun, doubtless it would have been well with me.

Up here at least I have dismissed my foolish fears and made some progress in the art of not worrying. What joyous country may lie around a turn in the road which seemed to be running straight up to a precipice, I have learned this Winter. God grant I may make a more vigorous use of the rest of my life and my powers in the light of that knowledge.

Loses Fear of Men.

I was ready to use the negation of gentlemen for L. because of his suspicious and unworthy interpretations—his unwillingness to credit the ideal and the honorable and the generous in others (not that he is always that, but I felt he would be in certain lines). Perhaps it is because I have been too slow to develop the aristocratic and chivalrous virtues myself that I have stood off suspicious of man and life. A hard experience may make the most honorable gentleman suspicious and pessimistic in his attitude toward people, but however unfair and insulting one may feel his estimate of one's self, one will always feel that he is open-minded to the exonerating evidence, since he must believe from his own character—in the actuality of disinterested honor. While to the variet—the moral Philistine—what is the use of talking? He will only say—or think—"Methinks the lady doth protest too much" and sink deeper in the slough of suspicion.

But I have grasped some valuable things from this sojourn in the wilderness. Chiefly a new faith in men, or rather a confidence in my essential

safety with them, a new ability to get good from all sorts and conditions of them. I feel sure, someway, that I shall always be a braver and stronger woman than I was before last Fall; better able by far to take things as they come and do my work, to—

Argue not
Against heaven's hand or will, nor
hate a jot
Of heart or hope, but will bear up and steer,
Right onward.

June 4, 1915

I'm in the true author rage at editorial "tyranny." The person who selected and now and then revised doubtless meant honest, but he wasn't working in dense solitude, poor thing. Only he really should not, even at that, have made Emerson talk like Greenwich Village. I wrote Emerson says if you are popular in your set, it is a bad sign, but if people look at you with strange looks of respect and half dislike, you are probably right.

Appendix D
Newspaper Article by Alice Gray

Chicago Daily Tribune

July 26, 1916

"Back to Dunes, Says Alice Gray After City Tour: 'Nymph' of Indiana Shore Finds Movies and Pier Sights Tedious."

Bits of Philosophy

Miss Alice Gray, the "nymph of the dunes," came back yesterday to the civilization she had deserted—and missed her usual afternoon plunge in Lake Michigan.

She came in metropolitan raiment borrowed from a neighbor vacationing on the sands. The "nymph," in a tan suit, white oxfords and a floppy hat with pink ribbons, was much as she had been in her brilliant days as a student in the University of Chicago, although hot and uncomfortable. The city's clothes and ways were heavy and wearisome and she longed for the solitude of the sands almost the moment after her arrival.

The blare of wealth and noise, however, gave her few impressions. Only the stretches and the deep silences could bring forth enthusiasm from her. This is what she wrote:

Appendix D

By Alice Gray

I knew very well I shouldn't have any "impressions" on a first night back in town. The things I disliked annoy me less, for the time at least. I walked up and down the new pier without quite the aversion I had for Jackson Park beach after it was crowded; boats and patches of darkness are oases in the desert of glare, and one hopes the people in the chairs may be happy.

It takes perhaps an hour in the street car for the average Chicagoan to get there. But your millions for this, and not a quarter of a million to save the dunes from being Garyized, with the dunes now only an hour away by train. Is this forward-looking Chicago?

Never a Movie Fan

I went for the first time in my life to the movies—The Tribune's German war pictures. It is a shock to have one's usual impressions vanish so quickly; only the marching lines have something of the satisfying satiety of the fleeting eternal waves. I can sense something of the charm of the movies—far more than I had expected. But I think I could never be a move fan unless the scenes were far longer—a vast review, perhaps.

Yes, one loves him, the trim shouldered German infantryman. The rapidity with which the scene vanishes is almost a stab. But the marchers are much better; a big review one fancies might have the satisfying sense of stability of the mutably eternal waves themselves.

Durability of Movies

I got some sense of the charm of the movies. But I wonder if we shall really feel them as art so long as they have that torturing sense of evasiveness? It is the essence of the temperal.

But the weight of these stretches! After all, is anything else in the world real but that?

How does it seem to have a good city dinner again with the dancers gliding by and to walk over the new pier and through crowds, and ride on street cars, and sit at a desk in a busy office and even to glimpse vanity? Write about that as about the dunes, requests The Tribune lady who has been personally conducting a first night back in town.

Newspaper Article by Alice Gray

Loves Silence of Dunes

My dear, I can't; and to say why would be to discourse on the distinction between the artist and the journalist. I love the great silent darkness up there; the silence that lives in the noise of winds and water, the darkness that finds itself in the fleeting, eternal waves of those reaches of waste sand; the only reality of life for me is there. But the tireless officiating of those war endeavors in the movies, and the heaviness of those stretches of wounded soldiers, they indeed rebuke me and make me futile and self-indulgent, willful and whimsical.

Not Old Haunts

The sights I have seen on a night back in town have been not my old haunts but new experiences, though of types I had known and disliked or else expected not to like.

Then, as to the pier, I used to call down upon myself the charge of snobbishness by expressing the opinion that it was a waste of the lake front to give it up to amusement parks, the city life to tarnish the lake air.

The fisherman down by me much prefer their work in the open to its alternative switching and stoking in Hammond, but whatever they are doing, their idea of real life is short periods of hard work and long intervals of idleness on the lake.

Silken Sheen vs. Solitude

But the city dinner, after that primitiveness in things culinary on the dunes and steps before the meal is ready and eaten, was satisfying, indeed. The flower-like silken gowns of the diners, the gleaming dining room, they impress one after nine months of solitude away from all life.

But the silences and darkness out there are what I love. I must go back to them at once.

Appendix E
"Chicago's Kinland"

Essay by Alice Gray

Read on April 6, 1917, at Fullerton Hall, Chicago, Illinois

Chicago is used to thinking of herself as the child of Lake Michigan, in the prosaic sense of her commercial origin; for the lake not only gave her her water-borne trade, but deflected the land routes between East and Northwest so as to make her the inevitable railroad center of the country. The lake is literally her alma mater, the mother who fed her.

But when we come to form myths on our geological knowledge—as the Greeks did on their guesses—as to the origin of our city, we shall think of her as the child of Lake Michigan in a more poetic sense.

The great glacier, or ice sheet, which once extended over the Middle West down to the Ohio river, melted, gradually covering the surface level and deep with its rich black soil, until it had reached about the present limits of Chicago. Here the glacier stopped and stood still for a long time, leaving a deeper deposit which forms a ridge a few miles wide encircling the Chicago plain. This runs from Maywood and LaGrange through Palos Springs to Dyer, Indiana, and thence northeast to within three or four miles of the lake

shore. As the glacier melted further, the water stood in a little lake between this ridge and the ice, with its outlet to the southwest through the DesPlaines river. This lake—which, as its level lowered, retreated to the east and north and finally found a northern outlet—has for obvious reasons been given the name Lake Chicago, though it might be said to be Lake Michigan in her childhood.

So the glacier which came down from the north to give Illinois its chief treasure—its deep, rich soil—tarried at Chicago on the way back to give birth to the lake. The lake, when it retreated, left the Chicago plain leveled ready for the city. To the east, in Indiana, it left a somewhat narrower strip of fine level sand. In this the northwest wind, having shared with Chicago its vigor and joy and renewed its delight as it passed over the lake, has moulded the Dunes.

So the Indiana Dune country, like Chicago herself, is the child of Lake Michigan and the Northwest Wind. It is, indeed—

The land her great wind gave her from her lake,
Where naught of man's endures before the suns.

Besides its nearness to Chicago and its beauty, its spiritual power, there is between the Dune Country and the city a more than sentimental bond—a family tie. To see the Dunes destroyed would be for Chicago the sacrilegious sin which is not forgiven.

As a dower for her sons and her daughters
The heedless young city shall take
This gift of the wind and the waters
From her mother, her lake.

Notes

Introduction

1. Earl H. Reed, *Sketches in Duneland* (New York: John Lane Company, 1918).
2. P.S. Goodman, letter to the editor, *Chicago Daily Tribune*, June 22, 1921. Goodman defended his naming of the dune peaks for Prairie Club members and one for Diana. He wrote: "I confess to placing Diana's name on the map, but does not public interest in Miss Gray justify it?" P.S. Goodman, map of Indiana dunes (Chicago: Rand McNally & Co., 1920).
3. *Chesterton Tribune*, "Nymph Alice Now a Diana," November 16, 1916.
4. *Chicago Examiner*, "Diana of Sand Dunes' is Found, She's a Graduate of U. of Chicago," July, 24,1916.
5. Ibid.

Chicago Childhood

6. Dominic Pacyga and Ellen Skerrett, *Chicago: City of Neighborhoods* (Chicago: Loyola University Press). 1986
7. Commission on Chicago Landmarks and the Chicago Department of Planning and Development, "Chicago Historic Resources Survey: Community Area no. 59, McKinley Park," City Hall, 1996.

8. The city's Bureau of Vital Statistics has no birth certificate for Alice Gray because, at the time, only hospital births required record keeping. The U.S. census of 1910 indicates her birth date as March 25, 1881; the date is also confirmed by her transcript at the University of Chicago. Her death certificate, containing information provided by a nephew, incorrectly states her birth date as November 25, 1881.
9. Illinois Labor History Society, "The Chicago Stockyards on the Eve of the CIO," 1936, http://www.kentlaw.edu/ilhs/stkyards.htm.
10. *Chicago Daily Tribune*, "Silver Anniversary of a High School," May 27, 1900.
11. Ibid.
12. *Chicago Daily Tribune*, "South Division High School," June 28, 1895.
13. South Division was later renamed Wendell Phillips High School and relocated.
14. *Chicago Daily Tribune*, "End High School Days," June 25, 1897.

Ambrose and Sallie Gray

15. *Chicago Herald and Examiner*, "The Diary of Diana of the Dunes," June 2, 1918.
16. United States Pension Agency affidavits.
17. Ann Turner, "Guide to Indiana Civil War Manuscripts," 1965, Indiana Civil War Centennial Commission, Indianapolis.
18. United States Pension Agency affidavits.
19. The location is now a parking lot.
20. United States Pension Office records.
21. Ibid.
22. Ibid.
23. Ibid.
24. Marion Noble LaRocco (daughter of Dorothy Dunn Noble, who was Alice Gray's niece and the daughter of Alice's sister, Leonora Dunn), in an interview with the author, May 20, 2010. LaRocco shared some favorite family stories about Alice. Unfortunately, the family's photographs of Alice Gray were lost during a move.
25. Dorothy Dunn Noble (Alice Gray's niece), audiotape recording retelling family stories about Alice. The tape was made by the LaRocco family but is currently missing.

Phi Beta Kappa

26. *Chicago Daily Tribune*, "Decennial Day Given to Lore," June 18, 1901.
27. *New York Times*, "Diana of the Dunes Dies of Privations," February 10, 1925.
28. Department of Mathematics, "The Mathematics Genealogy Project," North Dakota State University, http://genealogy.math.ndsu.nodak.edu/id.php?id=5879.
29. G.A. Bliss, "Autobiographical Notes," *American Mathematical Monthly* 59, no. 9 (November 1952): 595. Mathematical Association of America, http://www.jstor.org/stable/2306763.
30. Jusserand's Pulitzer Prize–winning book is titled (*With Americans of Past and Present Days*, published in 1916.)

From the USNO to Germany

31. *Delphos Daily Herald* (Delphos, OH), "Women in the Employ of the Government," January 16, 1903.
32. Ibid.
33. *The Contributions of Women to the United States Naval Observatory: The Early Years*, 1997, http://maia.usno.navy.mil/women_history/history.html.
34. *Oral History Interview with Alfred H. Mikesell*, U.S. Naval Observatory Oral History Program.
35. *Contributions of Women*.
36. Olga Mae Schiemann, personal letter, 10 November 1954, Sisters of Providence Archives, St. Mary-of-the-Woods, Indiana.
37. The information was provided by Martha Connelly, as researched by her former student, Anika Schusser. Connelly is a senior lecturer at the University of Heidelberg in Heidelberg, Germany.
38. The University of Gottingen did not record information about what a particular student studied; furthermore, visiting students' transcripts left the institution when the student did, in their own care.
39. Schiemann, personal letter, 10 November 1954, Sisters of Providence Archives.
40. *Chicago Herald and Examiner*, "Diana of Dunes Loses Fear of Men," June 6, 1918.
41. *Chicago Herald and Examiner*, "Diana of the Dunes Dissects Soul in Diary," June 3, 1918.

Leaving Chicago

42. Thomas H. Cannon, H.H. Loring and Charles J. Robb, eds., *History of the Lake and Calumet Region of Indiana: Embracing the Counties of Lake, Porter and LaPorte* 1 (Indianapolis, IN: Historians' Association Publishers), 1927.
43. The University of Chicago cannot verify this employment history.
44. Olga Mae Schiemann, personal letter, 21 June 1952, Sisters of Providence Archives, St. Mary-of-the-Woods, Indiana.
45. *Chicago Herald*, "Nymph of Dunes Gives Interview," July 23, 1916.
46. The diary is appended.
47. Taken from an article in the *Chicago Examiner*, July 23, 1916, lost to history but often quoted in early works about Alice Gray.
48. *Chicago Herald and Examiner*, "Diana of the Dunes Dissects Soul in Diary," June 3, 1918.
49. *Fort Wayne Weekly Sentinel*, "'Diana of the Dunes,' Fled from the World of Men, Discloses Mystery of Weird Life to Woman," August 1, 1916.
50. *Chicago Herald*, "Nymph of Dunes Gives Interview," July 23, 1916.
51. *Porter County Vidette*, "Mystery Still Hangs About Hermit Woman," July 26, 1916.
52. *Chicago Herald*, "Nymph of Dunes Gives Interview," July 23, 1916.
53. *Chicago Herald and Examiner*, "Diana of the Dunes Dissects Soul in Diary," June 3, 1918.
54. *Chicago Herald and Examiner*, "The Diary of Diana of the Dunes," June 2, 1918.
55. *Chicago Herald and Examiner*, "Diana of the Dunes Says 'L' Brought Her Sunshine," June 2, 1918.

Driftwood

56. *Chicago Herald and Examiner*, "The Diary of Diana of the Dunes," June 2, 1918.
57. *Lake County Times*, "Nymph Is Plump and Forty," July 24, 1916.
58. *Fort Wayne Weekly Sentinel*, "Diana of Dunes Fled from World of Men, Discloses Mystery of Weird Life to Woman," August 1, 1916.
59. The site was eventually designated as the Richardson Wildlife Sanctuary. A house was built there in the 1950s; it has since been razed.
60. Edward C. Howell, memoir, Westchester Township Historical Society.
61. *Gary Evening Post*, "Woman Hermit of Sand Dunes Tells Sad Tale," July 24, 1916.

62. *Chicago Herald and Examiner*, "The Diary of Diana of the Dunes," June 2, 1918.
63. Ibid.
64. *Chesterton Tribune*, "Nymph 'Alice' Now a 'Diana,'" November 16, 1916.
65. Schiemann, personal letter, 21 June 1952, Sisters of Providence Archives.
66. Schiemann, personal letter, 10 November 1954, Sisters of Providence Archives.
67. Margaret A. Larson, M*emoirs of Old Baileytown 'Plus'* (1999; Portage, IN: V.L. Montreuil, 1998).
68. The home of Agnes Larson now serves as the Indiana Dunes National Lakeshore Learning Center and is located at 700 West Howe Road in Chesterton.
69. *Gary Evening Post*, "Woman Hermit of Sand Dunes Tells Sad Tale," July 24, 1916.
70. *Chicago Herald and Examiner*, "The Diary of Diana of the Dunes," June 2, 1918.
71. *Chicago Herald and Examiner*, "Diana of Dunes Loses Fear of Men," June 6, 1918.
72. *Gary Evening Post*, "Woman Hermit of Sand Dunes Tells Sad Tale," July 24, 1916.
73. *Prairie Club Bulletin*, March 1925.
74. *Lake County Times*, "Nymph of Dunes Is Heard from Again," April 6, 1917.
75. Schiemann, personal letter, 21 June 1952, Sisters of Providence Archives.
76. Oral histories, Westchester Historical Museum.

77. *Chicago Herald and Examiner*, "Diana of the Dunes Dissects Soul in Diary," June 3, 1918.
78. Ibid.
79. *Chicago Herald and Examiner*, "The Diary of Diana of the Dunes," June 2, 1918.
80. Ibid.

Surfacing in the Dunes

81. Earl H. Reed, *The Dune Country* (New York: John Lane Company, 1916).
82. *Gary Tribune*, "100 Degrees in Shade: Hottest Gary Has Known," July 24, 1916.

83. *Porter County Vidette*, "Luna Slips Into the Earth's Shadow," July 19, 1916.
84. *Gary Evening Post*, "National Dune Park Campaign Launched," July 17, 1916.
85. *Lake County Times*, "Adam May Find Six New Eves," July 17, 1916.
86. *Porter County Vidette*, "Five Women Have Valpo on Hiker's Route," July 12, 1916.
87. *Lake County Times*, "What Will These Women Try Next?" July 15, 1916.
88. *Lake County Times*, "Gary Boy Scouts to Capture Shark," July 14, 1916.
89. *Lake County Times*, "Small Shark Seen East of Miller," July 14, 1916.
90. *Lake County Times*, "Ask for Fair Play at Beach; 2 Hrs. Long Enough for Sport," July 22, 1916.
91. *Lake County Times*, "Miller Beach Crowded Sunday," July 24, 1916.
92. *Gary Tribune*, "Lake Road Not Large Enough for All Bathers," July 31, 1916.
93. *Chicago Herald*, July 30, 1916.

Diana of the Dunes

94. *Lake County Times*, "Mystic Nymph in Wild Dunes," July 22, 1916.
95. *Lake County Times*, "Cave Man? Hist Alice Wake Up!" December 10, 1918.
96. *Gary Evening Post*, "Mystic Nymph in Wild Sand Dunes," July 22, 1916.
97. *Chicago Herald*, "Nymph of Dunes Gives Interview," July 23, 1916.
98. *Lake County Times*, "Mystic Nymph in Wild Dunes," July 22, 1916.
99. *Lake County Times*, "Nymph Is Plump and Forty," July 24, 1916.
100. *Chicago Herald*, "Nymph of Dunes Gives Interview," July 23, 1916.
101. *Lake County Times*, "Nymph Is Plump and Forty," July 24, 1916.
102. *Chicago Herald*, "Boys Bathe in Fountain as U. of C. Co-Eds Shriek," July 25, 1916.
103. *Gary Daily Tribune*, "Is This a Scheme to Attract People to Dune Region?" July 22, 1916.
104. *Lake County Times*, "Suggests a Park at Dunes with Diana in Charge," July 26, 1916.
105. Ibid.
106. *Lake County Times*, "Nymph O' Dunes Visits Chicago," July 26, 1916.
107. *Chicago Daily Tribune*, "Back to Dunes, Says Alice Gray After City Tour; 'Nymph' of Indiana Shore Finds Movies and Pier Sights Tedious," July 26, 1916. The full text of this article is appended.

108. Ibid.
109. *Gary Evening Post*, "Diana Dunes May Go Back to Life," July 26, 1916.
110. *Porter County Vidette*, "'Diana of the Dunes' Flees Her Habitation," July 26, 1916.
111. *Chicago Herald and Examiner*, "Diana of the Dunes Says 'L' Brought Her Sunshine," June 4, 1918.

FULLERTON HALL

112. Alice Gray, "Chicago's Kinland" (essay, Fullerton Hall, Chicago, IL, April 6, 1917). This essay, courtesy of Westchester Township History Museum, is appended.
113. "American Memory," Library of Congress, http://memory.loc.gov. Both photographs are available for viewing online by doing a search for "Alice Gray" on the website.
114. *Chesterton Tribune*, "'Diana of the Dunes' to Appear on Platform," April 5, 1917.
115. "The Dunes Under Four Flags," Dunes Pageant Association, 1917.
116. *Lake County Times*, "Nymph of Dunes Is Heard from Again," April 6, 1917.
117. This essay, courtesy of Westchester Township History Museum, is appended.

PAUL WILSON: CAVEMAN

118. Joseph Thomas, ed., *A History of Ogden Dunes* (n.p.: 1976).
119. *Evening Messenger*, "Picturesque Characters Have Left the Duneland," December 5, 1923.
120. *Michigan City News*, "Dunes Rover Is Identified as Former Resident," June 16, 1922.
121. *Michigan City News*, "Denial by Eisenblatters," June 17, 1922.
122. *Times* (Hammond, IN), "Caveman Husband of Diana Reveals His Life Story," June 23, 1922.
123. *Chicago Herald and Examiner*, "6 Foot 2 Inch Caveman Wins Dunes' Diana," June 27, 1920.
124. Their historic house still stands today.

125. *Chicago Herald and Examiner*, "The Diary of Diana of the Dunes," June 2, 1918.
126. *Chicago Herald and Examiner*, "Diana of the Dunes Dissects Soul in Diary: Tells of Preparing New Book," June 3, 1918.
127. *Times* (Hammond, IN), "Caveman Husband of Diana Reveals His Life Story," June 23, 1922.
128. *Chesterton Tribune*, "Diana's Caveman Tells How He Met the Nymph of the Dunes," June 29, 1922.
129. *Evening Messenger*, "Picturesque Characters Have Left the Duneland," December 5, 1923.
130. Samuel Reck, developer of Ogden Dunes, recalled making the same suggestion to Paul as a means of income.
131. Ibid.
132. Thomas, ed., *A History of Ogden Dunes*.

Murder in the Dunes

133. *Evening Messenger*, "Diana Suffers a Fracture of Skull," June 14, 1922.
134. *Evening Messenger*, "Found Dead and Cremated at Waverly," June 9, 1922.
135. *Gary Evening Post and Daily Tribune*, "'Diana' Knows Nothing of Dunes Death Mystery," June 10, 1922.
136. *Evening Messenger*, "Sand Dune Stranger Is Identified," June 10, 1922.
137. *Chicago Herald and Examiner*, "Dunes Victim Is Believed Identified," June 11, 1922.
138. *Chicago Herald and Examiner*, "Dunes Slaying 'Victim' Sees 'His' Death Pyre," June 12, 1922.
139. *Gary Evening Post*, "Hurried Visit of Beautiful Girl to Sand Dunes Where Charred Body of Unknown Man Was Found May Solve Latest Death Mystery," June 13, 1922.
140. Complaint for Damages, filed in the District Court of the United States for the District of Indiana, June 9, 1924: *Paul George Wilson and Alice Gray Wilson, Plaintiffs v. The Evening American Publishing Company, and the Tribe of K., defendants.*
141. *Times* (Hammond, IN), "Dunes' Diana in Hospital Badly Hurt; Woman's Protector Shot in Foot and Her Skull Is Fractured in Battle on Sands," June 14, 1922.
142. Ibid.

143. *Gary Evening Post*, "Diana's Cottage Broken Into by Curiosity Seekers, Claim—Her Cave-Man Mate Gives His Version of Fight in Which Diana Was Injured," June 17, 1922.
144. Ibid.
145. *Gary Evening Post*, "Husband of Diana Gives First Clue," June 14, 1922.
146. *Daily Herald* (La Porte, IN), "Caveman Mate Bares Attack," June 15, 1922.
147. *Gary Post-Tribune*, "First Pictures of Sand Dunes Cottage of Diana and Her Mate," June 19, 1922.
148. *Gary Evening Post*, "Diana's Cottage Broken Into by Curiosity Seekers, Claim—Her Cave-Man Mate Gives His Version of Fight in Which Diana Was Injured," June 17, 1922.
149. *Gary Post-Tribune*, "Original 'Diana of the Dunes' and Mate Flee as Civilization Intrudes," November 23, 1923.
150. *Lake County Times*, "Has Diana Left the Dunes? Never!" April 23, 1923.

A Case of Libel

151. *Evening Messenger*, "Picturesque Characters Have Left the Duneland," December 5, 1923.
152. *Gary Post-Tribune*, "Dunes Route Formally Opened," November 16, 1923.
153. *Chesterton Tribune*, "Dunes Hiway Dedication a Great Success," November 22, 1923.
154. *Gary Post-Tribune*, "20,000 Autos Use New Dunes Route Sunday," November 20, 1923.
155. *Gary Post-Tribune*, "Will Unload Machinery at Dune Station," November 14, 1923.
156. *Lake County Times*, "Giant of Duneland Is Fined," June 25, 1923.
157. *Gary Post-Tribune*, "Original 'Diana of the Dunes' and Mate Flee as Civilization Intrudes," November 23, 1923.
158. Ibid.
159. Ibid.
160. Ibid.
161. Thomas, ed., *A History of Ogden Dunes*.
162. Ibid.
163. Legal documents obtained courtesy of the National Archives, Great Lakes Region, Chicago, Illinois.
164. *Gary Evening Post*, "Diana of the Dunes Starts $100,000 Suit: Charges Newspaper with Libel," June 10, 1924.

165. Legal documents obtained courtesy of the National Archives, Great Lakes Region, Chicago, Illinois.
166. Complaint for Damages, filed in the District Court of the United States for the District of Indiana, June 9, 1924: *Paul George Wilson and Alice Gray Wilson, Plaintiffs v. The Evening American Publishing Company, and the Tibe of K. defendants.*
167. *Times* (Hammond, IN), "Diana of Dunes Reported Dead in Her Lonely Shack," February 9, 1925.

In the End

168. *Evening Messenger*, "Mystery Woman of Dunes Dies," February 10, 1925.
169. Thomas, ed., *A History of Ogden Dunes.*
170. *Gettysburg Times*, "Diana Dead," February 19, 1925.
171. *Helena Independent*, "Diana of Dunes Is Dead, Dancing in Moonlight on Sands of Shore at End," February 10, 1925.
172. *New York Times*, "'Diana of the Dunes' Dies of Privations," February 10, 1925.
173. *Syracuse Herald*, February 9, 1925. The subheadline of the story added more flavor: "Diana of the Dunes, Daughter of Wealthy Family Dwelt Nine Years Amid Privations—Wore Only Nature's Garbs."
174. Thomas, ed., *A History of Ogden Dunes.*
175. *La Porte Herald Argus*, "'Respectable' Funeral for Diana of the Dunes," February 11, 1925.
176. *Gary Post-Tribune*, "Diana, 'Dunes Nymph,' Is Laid to Rest in Oak Hill; Friends Donate Flowers," February 11, 1925.
177. Thomas, ed., *A History of Ogden Dunes.*
178. *Times* (Hammond, IN), "Paul Packs His Gun at Diana's Bier," February 12, 1925.
179. Thomas, ed., *A History of Ogden Dunes.*
180. Ibid.
181. *Times* (Hammond, IN), "Diana of Dunes Reported Dead in Her Lonely Shack," February 9, 1925.
182. *Times* (Hammond, IN), "Paul Packs His Gun at Diana's Bier," February 12, 1925.
183. Chester Dunn inadvertently provided an incorrect birth date on Alice Gray's death certificate. He stated she was born on November 25, 1881, when in fact it was March 25, 1881.
184. *Gary Evening Post*, "Diana Laid to Rest; Mate Not at Grave," February 12, 1925.

185. Thomas, ed., *A History of Ogden Dunes*.
186. *Vidette Messenger*, "Porter Township History," Porter County Centennial Edition, August 16–21, 1936.

APPENDIX B: PAUL WILSON, AFTER ALICE

187. *Fresno Bee* (Fresno, CA), "Haunted by the Spirit of 'Diana of the Dunes,'" April 26, 1925.
188. Ibid.
189. *Gary Post-Tribune*, "Seek Husband of 'Diana' on Plea of Wife," March 14, 1927.
190. *La Porte Herald Argus*, "Wilson Accused of Shooting Gun," April 29, 1926.
191. *Gary Post-Tribune*, "'Diana's' Mate, After Period of Obscurity, Again Behind Bars," April 28, 1926.
192. Introduction, Henrietta Martindale Hyessa Wilson (1888–1962) and Family Papers, 1896–1977, Murphy Library, University of Wisconsin–La Cross. http://digicoll.library.wisc.edu/cgi/f/findaid/findaid-idx?c=wiarchives;view=reslist;subview=standard;didno=uw-whs-lx00bd;focusrgn=C01;cc=wiarchives;byte=68908068
193. *Gary Post-Tribune*, "Seek Husband of 'Diana' on Plea of Wife," March 14, 1927.
194. Ibid.
195. Charles Eastman (1858–1939) was a Native American physician. He is well known for his work in promoting American Indian rights. Eastman cared for Indians after the Wounded Knee massacre and helped to found the Boy Scouts of America.
196. *Gary Post-Tribune*, "Echo of 'Diana of the Dune' Is Heard Again," March 17, 1927.
197. *La Porte Herald Argus*, "Giant of Dunes Is Jailed Here," March 17, 1927.
198. *La Porte Herald Argus*, "Eats Matches in Suicide Attempt," March 16, 1927.
199. *Vidette-Messenger*, "Paul Wilson Is Freed on Bond," December 2, 1930.
200. Ibid.
201. *Chesterton Tribune*, "Wilson Home on Dunes Highway Burns Monday," January 1, 1931.
202. *Vidette-Messenger*, "Paul Wilson in Jail Again," January 5, 1931.
203. *Vidette-Messenger*, "Dunes Giant, Man of Woes, Made Convict," February 6, 1931.

204. Document on file with the Indiana State Archives, Indiana Commission on Public Records.
205. *Bakersfield Californian*, "Unidentified Man Discovered Dead," October 27, 1941.
206. *Bakersfield Californian*, "Dead Man Found in Cabin Is Identified," October 28, 1941.

About the Author

Photograph by Craig Berg

Although this marks her first book-length work, Janet Zenke Edwards has long written about fascinating, unusual and otherwise remarkable people whose stories have appeared under her byline in newspapers, magazines and essays. She lives with her husband and three children in St.Louis, Missouri. Every summer she is grateful for time spent at the family's third-generation cottage along Lake Michigan's shoreline—within walking distance of where Alice Gray first settled in the Indiana dunes.

Visit us at
www.historypress.net

This title is also available as an e-book